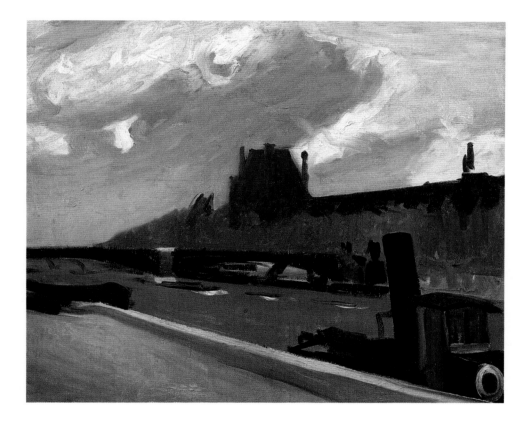

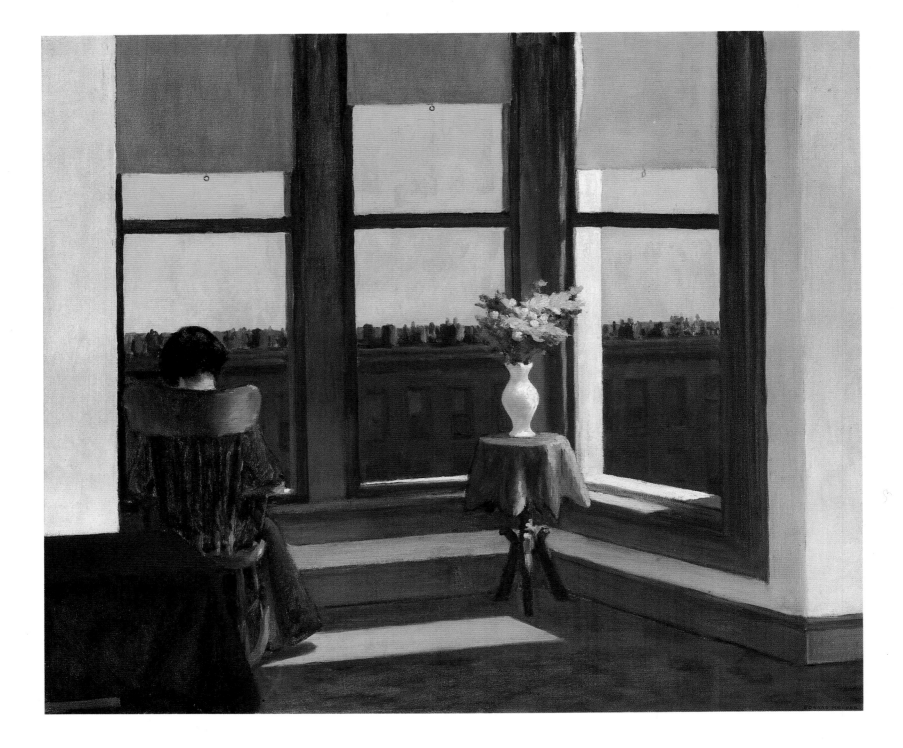

# Edward HOPPER

JG PRESS

Reprinted 2003 by
World Publications Group, Inc.
455 Somerset Avenue
North Dighton, MA 02764
www.wrldpub.com

ISBN 1-57215-350-4

Printed and bound in China by
Leefung-Asco Printers Trading Ltd.

10 9 8 7 6 5

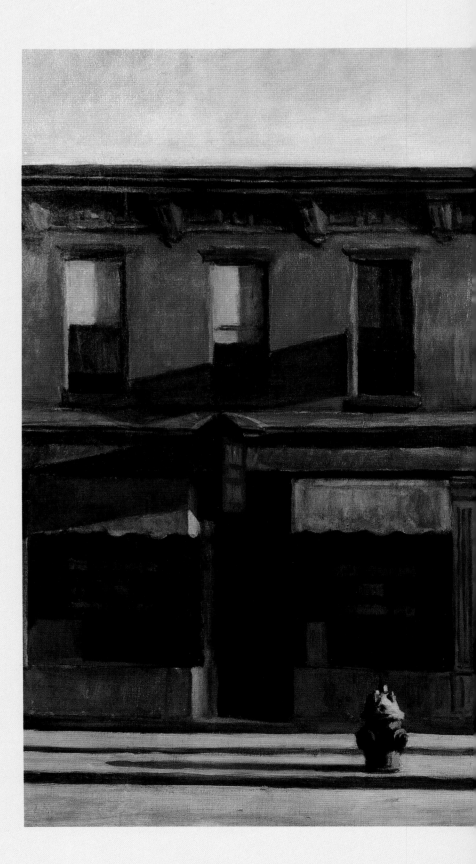

Page 1:
**The Louvre in a Thunderstorm,** 1909
Oil on canvas, 23×28¾in.
*Request of Josephine N. Hopper*
*Collection of Whitney Museum of American Art, New York, NY*
(70.1223)

Page 2:
**Room in Brooklyn,** 1932
Oil on canvas, 29×34 in.
*Charles Henry Hayden Fund*
*Courtesy of Museum of Fine Arts, Boston, MA*
(35.66)

Pages 4-5:
**Early Sunday Morning,** 1930
Oil on canvas, 35×60 in.
*Purchase, with funds from Gertrude Vanderbilt Whitney*
*Whitney Museum of American Art, New York, NY*
(31.426)

# Contents

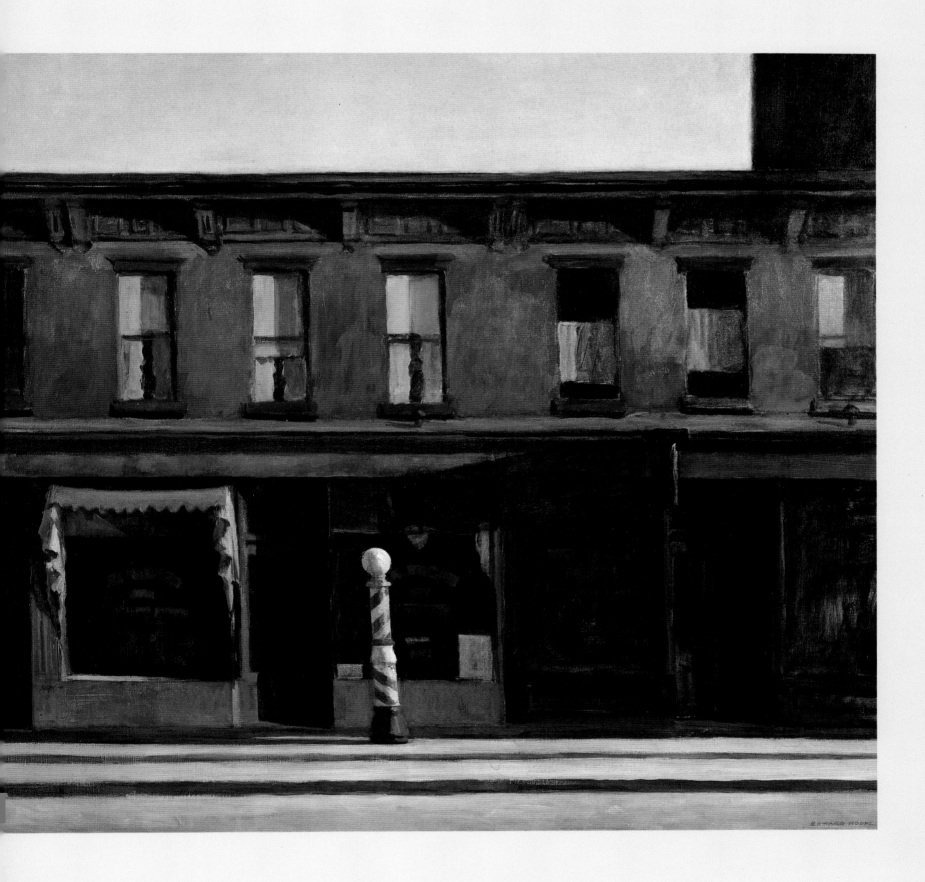

# INTRODUCTION

Edward Hopper, regarded by many as twentieth-century America's foremost realist painter, could well be seen as an example of one of America's most popular myths: the all-American success story whereby someone from humble, or at least unlikely, origins rises to the top of his profession. It is a characterization that probably would have horrified Hopper, who chose to see himself as being so atypical as to be isolated from the mainstream of both American society and American art. Yet this self-styled loner, who claimed to be unaware of any significant influences on his work and who disclaimed any greater purpose for his art than to "paint sunlight on the side of a house," has been called an examplar of the great American aesthetic tradition and the heir of such towering American painters as Winslow Homer and Thomas Eakins.

Hopper's cityscapes and scenes of small town streets, country farms and roads preserve an uncanny portrait of twentieth-century America during the years when modern life accelerated and left many Americans feeling as isolated as their ancestors had been on prairie homesteads. As fellow-painter Charles Burchfield said in 1950, "Posterity will be able to learn more about our life of today through looking at Hopper's work than from all the social schools, political comments or screaming headlines of the present."

Hopper was the first painter to emphasize the dark side of America's pellmell growth, to dwell on the forms of human isolation and impersonality that accompanied the country's seemingly invincible progress and expansion. "Hopper houses" and "Hopper people," as well as both urban and rural "Hopper

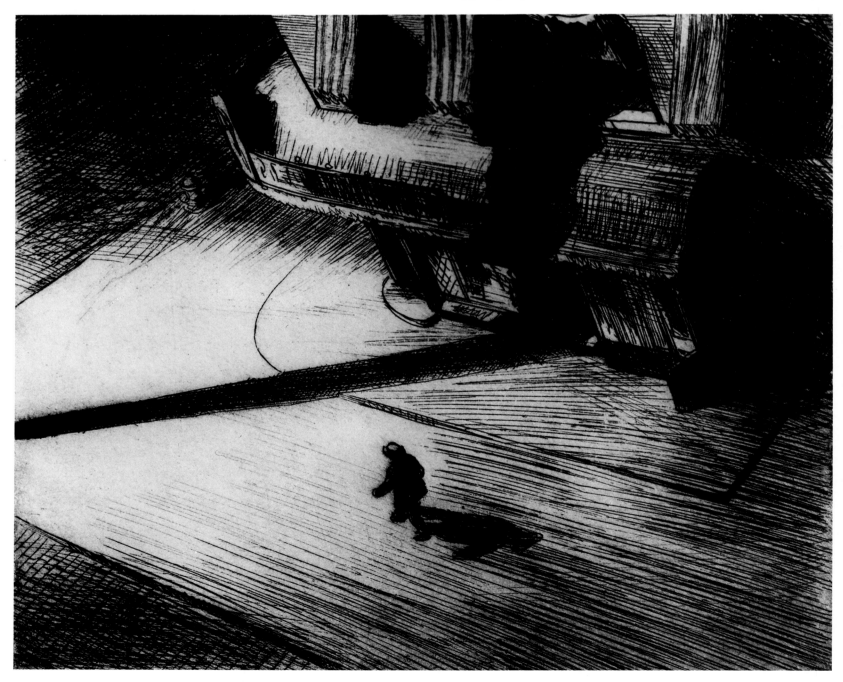

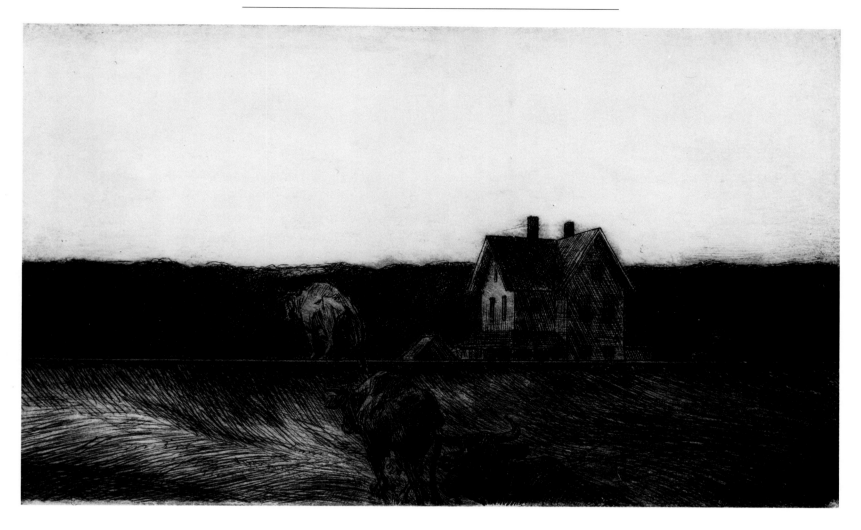

**Opposite:** *Night Shadows*, a 1921 Hopper etching in the collection of the Whitney Museum of American Art.

**Above:** *American Landscape*, a Hopper etching of 1920 that is also in the Whitney Collection in New York.

streets," are instantly recognizable, not just as creations of a gifted artist, but as reflections of a national reality. Hopper himself admitted that he painted much more than "sunlight on the side of a house" when he said that his aim in painting "has always been the most exact transcription possible of my most intimate impressions of nature." It is this combination of precise rendering and personal vision that makes the best Hoppers both immediately recognizable and unforgettable.

At first glance Edward Hopper's life seems as spare and simple as one of his works of art, but – like one of his paintings – Hopper's life requires considerably more than a glance to understand. He was born in 1882 in Nyack, New York, a yacht-building center on the Hudson River north of New York City. If there was artistic talent in this middleclass Baptist family, it was dormant: Hopper's father was a dry goods merchant, and his mother focused her energies on rearing Edward and his sister. When Hopper was seven his parents gave him a blackboard for Christmas, but instead of using it as a chalkboard, young Eddie turned it into his first easel. Eddie's sister also tried her hand at drawing, but it was her son's sketches that Mrs. Hopper

carefully dated and saved. Whether this was simply because he was the favorite child or because she perceived that his sketches were something more than childish scrawls is not known.

In later years Hopper sketched and painted both parents. His father had the piercing blue eyes his son inherited, and his mother, in her prime, appears to have been what was known at the time as "a fine figure of a woman" – fullbusted and Junoes-que – although Hopper's portraits of her in later years reveal a certain melancholy. As for Hopper himself, he must have been a striking – indeed, a startling – youth. When he was 12 a Paul Bunyanesque growth spurt left him more than six feet tall and turned his native shyness into the virtual reclusiveness of someone agonizingly self-conscious. As a young man Hopper did a number of self-portraits in pen and ink, charcoal, watercolors and oil, and in almost every one his head is slightly cocked and his gaze wary. Many who knew Hopper commented that he seemed forever bemused by his ungainly body. A friend said that watching Hopper get up out of a chair was like watching an erector set attempt to construct itself.

Like many parents of a sensitive and artistic son, the Hoppers were proud of their child's talent but concerned that he was too isolated from other children. Hopper remembered his father's repeatedly shooing him away from his easel and out of the house to play. It seems that Hopper took his sketch book along when he headed outside, and many of his first sketches were of the boats that were built and launched along the Hudson at Nyack. At 15 Hopper built his own catboat, but it was not a great success. "It didn't sail very well," he recalled, adding that it persistently "kept heading into the wind."

Despite this minor setback, Hopper was strongly tempted to become a ship designer when he finished high school, and he haunted Nyack's shipyards throughout his adolescence. Hopper's fascination with boats would produce a number of paintings over the years: the first oil he sold, at the famous Armory Show in 1913, was entitled *Sailing*. Significantly, as a mature painter Hopper chose not to paint the sleek yachts he'd seen as a boy in Nyack; his interest was in work-a-day boats. His scenes of tugboats, whether on the Hudson or the Seine, of fishing boats off the Maine and Massachusetts coasts and of working trawlers and beached dinghys have one thing in common: all reveal the eye and hand of someone who knows exactly how a boat is framed and skinned.

By the time he was graduated from Nyack High School in 1889 Hopper had given up the idea of becoming a naval architect and had determined on a career as an artist. Hopper's practical father, speaking from his perspective as a solid small-town merchant, managed to persuade his son to study commerical art, for the senior Hopper argued that if need be Eddie could always make a living as an illustrator – precisely what Hopper had to do for almost a quarter of a century.

Hopper first studied illustration during the winter term of 1889-1900 at New York's Correspondence School of Illustrating, but he moved on in 1900 to the more prestigious New York School of Art (also known as the Chase School, after artist William Merritt Chase). He spent the next six years there, initially concentrating on commercial art; after two years, he began to study painting with three of the best known teachers

of the day: Chase himself, Robert Henri and Kenneth Hayes Miller. Hopper was not the only student of his generation at the New York School who would make a name for himself: his fellow students included George Bellows, Rockwell Kent and Guy Pène du Bois (perhaps Hopper's only lifelong close friend) – as well as the future actor Clifton Webb and the poet Vachel Lindsay.

Hopper's mother had made some effort to expose her children to art by giving them illustrated books, and one of Hopper's earliest drawings was a copy of a figure by the 19th-century French illustrator Gustave Doré. Hopper was in fact relatively well-versed in art when he began his studies in New York at the age of 17, though he still knew a little of technique. He was fortunate that his three teachers had quite different teaching methods and styles: Rockwell Kent once said that Chase taught students to use their eyes, Henri, their hearts and Miller, their minds.

In his youth Chase had been something of a firebrand, one of a number of artists (including the great Thomas Eakins) who were allied in the so-called "New Movement" of the 1870s. The New Movement attempted to provide greater exposure for non-traditional and experimental artists by breaking the monopoly on exhibitions held by the prestigious National Academy of Design. To this end Chase, Eakins and others formed the Society of American Artists to sponsor avant-garde exhibitions. Ironically, by the 1890s the Society itself found Thomas Eakins too extreme and rejected his "Agnew Clinic" (1889) on the arbitrary grounds that it "neglected the beauties and graces of painting."

By the time that Hopper came to the New York School, Chase had become a pillar of the artistic establishment, increasingly criticized by a new generation of firebrands for what they perceived as his overly fussy emphasis on "the well-turned detail". As a teacher, Chase urged his students to draw upon the past, study great paintings and forge their own style from the common tradition. As Chase said, "Since we are dependent on others, let us frankly and openly take in all that we can . . . The man who does that with judgement will produce an original picture that will have value." Chase's classes at the Metropolitan Museum of Art were very popular – especially, Hopper later recalled somewhat peevishly, with young women.

Like Chase, Robert Henri wanted his students to become familiar with the artistic tradition, particularly the varying techniques of artists from Rembrandt and Velazquez to Goya, Manet and Degas. In fact, it was probably Henri who first introduced Hopper to the work of Degas, an artist whom Hopper, somewhat surprisingly, always singled out for high praise.

Despite his admiration for the old masters, Henri was by no means an academic. "It isn't the subject that counts but what you feel about it," he often said. "Forget about art and paint pictures of what interests you in life." To quicken his students' responsiveness to the world about them he would, for example, send them off to see Isadora Duncan dance. Henri also recommended that his students steep themselves in the poetry of

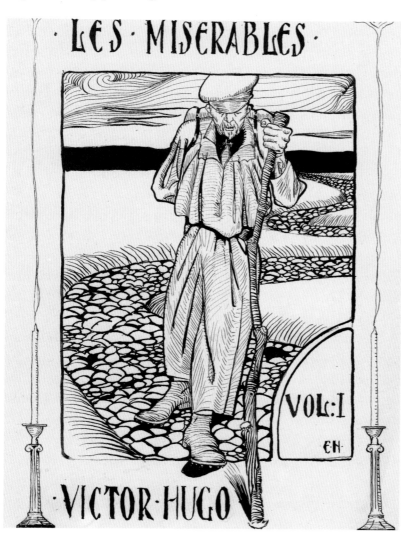

**Left:** Robert Henri, one of Hopper's teachers at the New York School of Art.

**Above:** John Sloan was, like Henri, one of the founders of the "Ash Can School."

**Opposite:** An illustration that Hopper made for Victor Hugo's *Les Miserables*.

Walt Whitman. Hopper, however, seems to have avoided Isadora Duncan and to have spent his time reading not Whitman, but Emerson. Hopper always considered Henri a brilliant teacher, but with the passage of time he would develop doubts about Henri's success as a painter. "It took me about ten years to get over Henri," he once observed. Certainly many of Hopper's somber early works show the influence of Henri's "dark palette" and "painterly" brush work.

Some years later, in 1908, Henri and seven friends (including John Sloan, whose New York scenes probably influenced Hopper), would stage a revolutionary show at New York's Macbeth Gallery. The group was known collectively in artistic circles as "The Eight," but it soon became better known as "The Ash Can School," an allusion to what the public perceived as most of The Eight's harsh focus on realism. The show shocked the public, sold out and led to a larger show of Independent Artists in 1910. It was followed in 1913 by the enormously influential International Exhibition of Modern Art, known as the Armory Show. Hopper exhibited in both the 1910 and 1913 shows, but his work was hardly avant-garde. In fact, as fellow-artist Charles Burchfield later pointed out, "Looking at the work of Hopper from 1913 on, you would never know that there had been an Armory Show at all."

In 1905, while still a student, Hopper began to work at the

C. C. Phillips advertising agency, founded by a former student of the New York School of Art. Almost immediately, and enduringly, Hopper detested the work, recalling that he would walk around and around the block before he could force himself to enter the office. In 1906, with his parents' help, he made a temporary escape from the world of commercial art: he sailed for France.

For at least a century most American artists had felt the need to make a European pilgrimage, and Hopper visited Europe three times between 1906-10, basing himself in Paris but making excursions to Germany, Holland, England and Spain. During these visits Hopper's tendency to be a loner became more pronounced: unlike most of his contemporaries, he studied with no one while in France, was part of no artistic circle and seems to have been unaffected by any of the fashionable new movements such as Fauvism, Cubism and Futurism. He later said that he "didn't remember having heard of Picasso at all" while there.

In later years Hopper seemed to contradict himself on the importance of his time abroad, remarking variously that "Paris had no great immediate impact on me," and that "It took me about ten years to get over Europe." What both remarks speak to is Hopper's almost obsessive need to see himself as a self-made artist. He insisted that "the only real influence I've ever

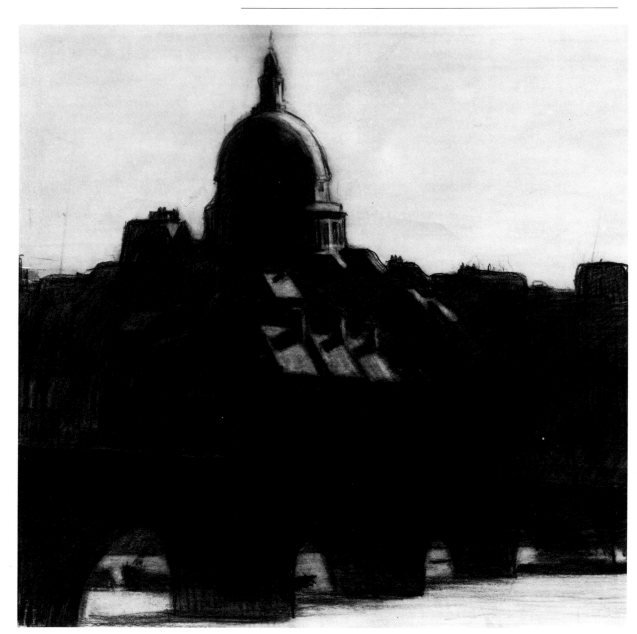

**Left:** Hopper's *The Dome* may reflect the influence of the French artist Charles Meryon.

**Below:** Another of Hopper's French scenes, *The Railroad*.

**Opposite top left:** This Hopper watercolor study of workmen with picks was made between 1916 and 1918.

**Opposite top right:** An illustration for a February 1919 issue of *Scribners*.

**Opposite below:** *The Bull Fight*, an etching *c.* 1917.

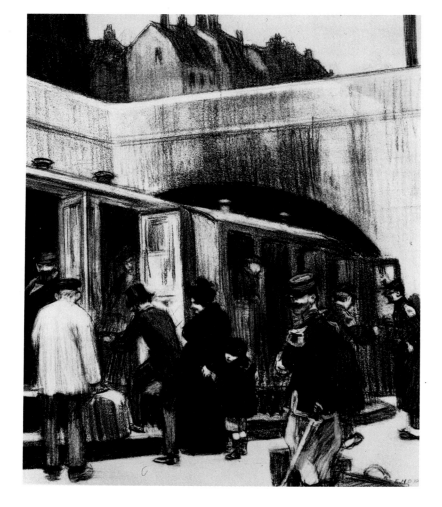

had was myself," and this belief led Hopper over the years to minimize the effect on his work not merely of his European sojourn, but of his teachers, of the great artists of the past and of such contemporaries as John Sloan and Charles Burchfield. Thus for Hopper the influence of Europe, like that of Robert Henri, was something to be "gotten over," not assimilated.

Hopper did, however, admit to having been impressed – if not influenced – by the work of the French 19th-century engraver Charles Meryon, especially his scenes of Paris architecture. The composition of a work such as Hopper's *The Dome* seems to owe its brooding atmosphere to Meryon's *'L' Abside de Notre Dame,* and in 1919 Hopper paid tribute to one of Meryon's most famous etchings, *Le Stryge* ("The Vampire"), in a cover for the magazine *La France.* Meryon's influence may have been one reason that Hopper later took up etching; certainly some of Hopper's engravings echo the scenes and moods of Paris that Meryon himself had portrayed.

It seems to have been in Paris that the man who said that his highest aim was "to paint sunlight on the side of a house" first seriously began to study and experiment with capturing light. Again, Meryon, whom Hopper later praised for his ability to capture "the essence of sunlight," seems to have been influential. In addition, Patrick Henry Bruce, a fellow student

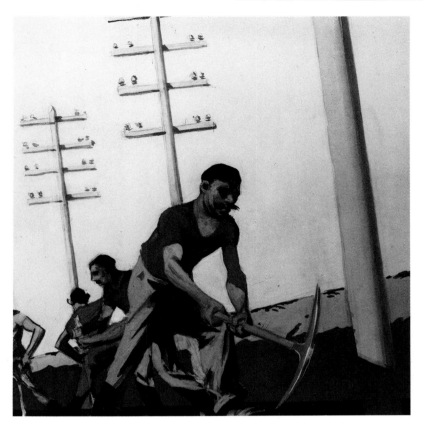

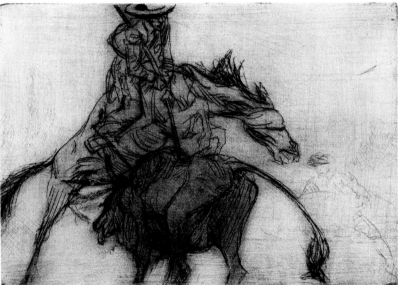

from the New York School of Art, introduced Hopper to the works of Pissaro and Sisley, whose own interest in rendering light is probably reflected in some of Hopper's Paris paintings. Most important, there was Paris itself. "The light," Hopper later recalled, "was different from anything I had known. The shadows were luminous, more reflected light. Even under the bridges there was a certain luminosity."

Back in America, Hopper found things "awfully crude and raw" and was haunted by images of Paris. Significantly, he entered an oil of *The Louvre* in the Independent Artists Exhibition of 1910, and four out of five of the works he submitted to an exhibit in 1912 were scenes of Paris. Yet Hopper chose to submit an American scene, *Sailing,* to the Armory Show of 1913. When the painting sold for $250 Hopper seemed to be on his way out of the hated world of commercial illustration, but he would be obliged to spend the next decade as a commercial artist and would not sell another painting until until the Brooklyn Museum bought *The Mansard Roof* for $100 in 1924.

Hopper was neither the first nor the last artist to have to make ends meet by doing illustrations: John Sloan, whose influence Hopper denied but clearly felt, had done commercial and newspaper work. Indeed, professional illustrators such as Joseph Leyendecker and Howard Pyle (and, in years to come, Norman Rockwell) were highly respected. But Hopper clearly felt it was beneath him to be forced to do commercial illustration for advertisements featuring straw hats, reversible coat collars and suspenders, or drawings for magazines like *System, Hotel Management, The Morse Dry Dock* and *Tavern Topics.* On the other hand, when the critic Albert Barr accused him of having turned out "pot boiling illustration", Hopper resented it and said he was proud of having won the U.S. Shipping Board Poster Prize for his World War I poster *Smash the Hun.* The war ended before the poster was used, but it later appeared on the cover of *The Morse Dial* in 1919. *Smash the Hun* is the only known example of Hopper's having worked from a photograph – something that even the great Eakins had done occasionally, and that other illustrators would do habitually.

In later years Hopper avoided the topic of his illustrations, and when it came up, he insisted that he had never spent more than three days a week serving Mammon, keeping the rest of the week free for his own work – what he once referred to somewhat bitterly as "the work at self-expression in spare time." Hopper recalled, "I was a rotten illustrator – or mediocre, anyway . . . I was always interested in architecture, but the editors wanted people waving their arms."

Although Hopper's feelings toward his commercial art were mixed at best, it is now accepted that many of the subjects that appear in his mature paintings first appeared in the work he did for hire: office, restaurant and hotel interiors, often with seemingly isolated figures, and bridges, trains and ships. Hopper himself once said, "In every artist's development the germ of

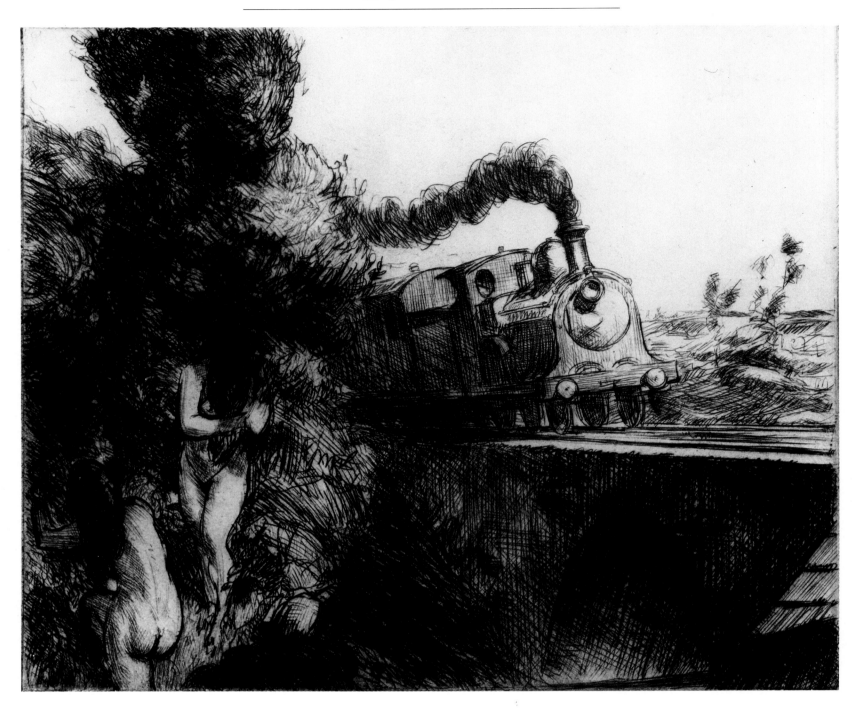

the later work is always found in the earlier," and this was true not merely of the topics Hopper chose, but of his style, when he was not forced to show "people waving their arms." What is lacking in Hopper's work as a commercial artist is, of course, the sense of silence, mystery and, often, bleakness that inform so many of his mature paintings.

In 1915, while supporting himself as an illustrator and painting in his spare time, Hopper took up etching. When asked later why, he simply said, "I wanted to etch, that's all." As always, Hopper was reluctant to admit influence in any aspect of his career, although Gail Levin, who has spent a lifetime studying the artist, has suggested that Hopper's impetus to etch – and some aspects of his early printmaking style – may have come not only from Charles Meryon but also from the young Australian printmaker Martin Lewis, whom Hopper met in New York in 1900. Lewis did a number of etchings of trains, factories and boats, as well as of Manhattan rooftops – all to become favorite Hopper subjects.

Walter Tittle, whose studio was next to Hopper's at 3 Washington Square North at this time, characterized Hopper when he began etching as "groping to find himself." Tittle continued: "Around his studio stood some canvases that he had produced in his Paris days . . . . He wanted to go on from there, but for a considerable period his principal product consisted of occasional caricatures in a style smacking of both Degas and Forain, and drawn from memories of his beloved Paris." Certainly, *Les Deux Pigeons* (1920), set at a Parisian outdoor cafe, is one of Hopper's finest etchings and one of his rare attempts at depicting relaxed sensuality. The couple in *Les Deux Pigeons* offers a striking contrast in mood to the man and woman shown deep in what seems to be troubled conversation in *Night on the El Train* (1920).

In all, Hopper produced almost 70 plates between 1915 and 1923. As a print maker, Hopper was fastidious; he prized Italian "Umbria" paper for its unusual whiteness and sent to Kimber in London for his black ink, "as I could not get an intense enough black here." If he had never painted a picture, Hopper's etchings probably would have won him a small, but secure, niche in the history of 20-century American art, for the best of them are exceptionally fine.

**Opposite:** *Train and Bathers*, a Hopper etching of 1920.

**Right:** *Les Deux Pigeons*, a nostalgic etching of 1920.

**Below:** The 1920 *Night on the El Train* prefigures much of Hopper's later work.

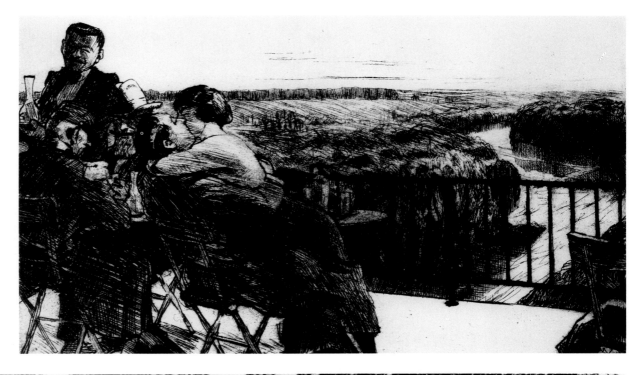

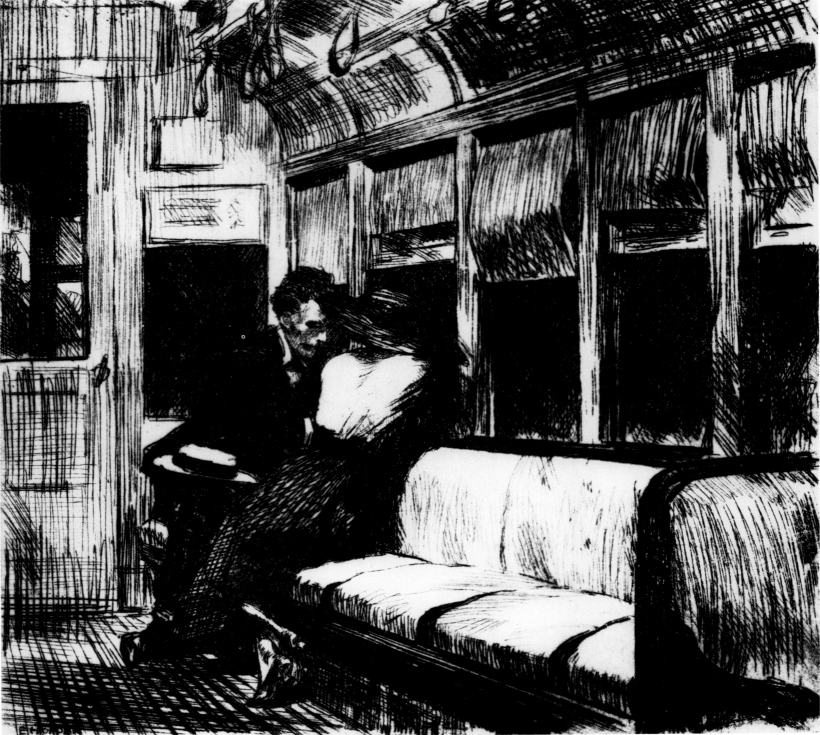

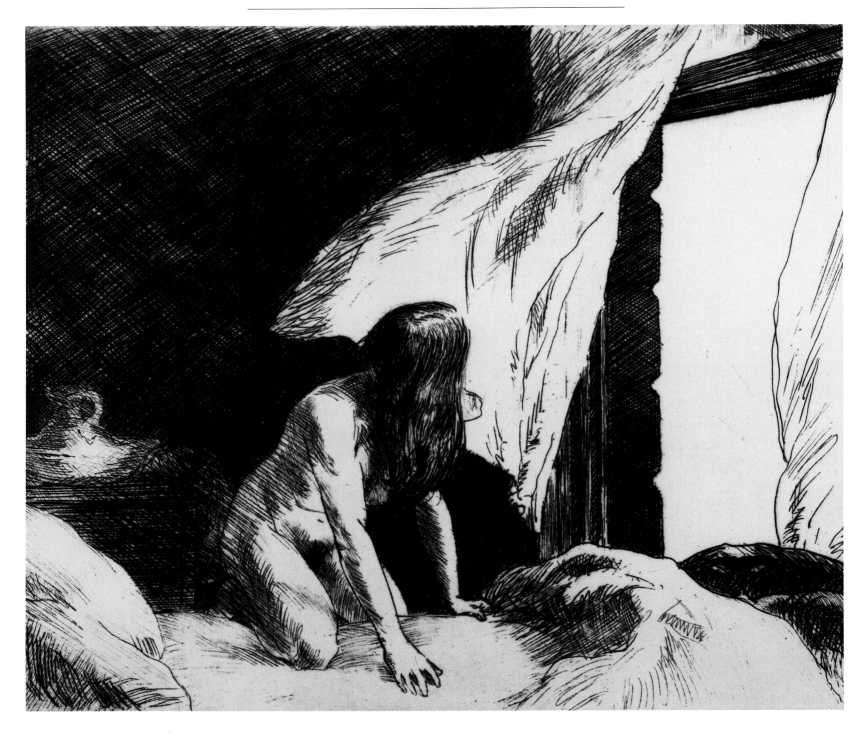

The etchings fall into three broad categories: portraits (the genre with which he was perhaps least comfortable), scenes remembered from his European travels and, increasingly, aspects of American urban and rural life. It was in this last group that Hopper began to find himself as an artist. This is especially evident in such urban scenes as *Night on the El Train, Evening Wind* (1921) and *Night Shadows* (1921) and in the rural subject *American Landscape* (1920), evidently a precursor of *House by the Railroad* (1925).

Regardless of his denials, it is hard not to think that Hopper was influenced, both as an engraver and as a painter, by John Sloan's scenes of New York rooftops and city streets. Sloan, like Degas, often showed a woman alone by a window, or highlighted in an interior, as in *Turning Out the Light* (1905), which virtually everyone *except* Hopper has seen as an influence on his *Evening Wind* (1921). But certainly Hopper made no bones about admiring Sloan, even comparing him to Degas in his ability to capture "the surprise and balance of nature."

Hopper also consistently denied that his paintings had any narrative or ideological content. When critics suggested that his *East Side Interior* (1922) – showing a woman seated before a sewing machine and looking out a tenement window – had some social implications, Hopper said this was untrue. "No implication was intended with any ideology concerning the poor and oppressed," he asserted. "The interior itself was my main interest – simply a piece of New York, the city that interests me so much, nor is there any derivation from the so-called 'Ash Can School' with which my name has at times been erroneously associated." Hopper was equally firm in disassociating himself with the "American Scene" school, although many critics see Hopper, like Thomas Hart Benton, Grant Wood, John Steuart Curry and Charles Burchfield, as a critical figure in forging an American idiom from realistic depictions of aspects of regional life. During the years when Hopper was supporting himself as a commercial artist and beginning to etch he never stopped painting, although his works were consistently rejected by all the major exhibitions, and a one-man show of oils at the Whitney Studio Club in January 1920 was not a suc-

cess. Even friends such as Sloan found his paintings "too harsh." At the same time, Hopper's etchings were beginning to enjoy some success, wining prizes at the National Academy and enjoying modest sales (for as little as $10 a print). It would have been understandable if Hopper had decided to concentrate on commercial art and etching, but he continued to put an enormous amount of time and energy into painting.

By living frugally – he bought his clothes at Woolworth's – Hopper managed to spend part of every summer at Gloucester, on Massachusetts' Cape Ann, or on the Maine seacoast. Increasingly, the summer months were devoted to watercolors, done outdoors, quickly, from nature, often without a preliminary sketch. By contrast, the etchings, many of which were of imagined or recollected scenes, involved a painstaking progress from sketch to plate to final print. Ultimately, in his oils, Hopper was to merge the two techniques, often making preliminary sketches of a scene, but actually painting in his studio. This way, he said, he was able to "get more of myself" into a painting than by working from nature.

In his watercolors he began to create a world that was uniquely his own; as he put it, "After I took up etching, my painting seemed to crystallize." Where Winslow Homer had painted the surf, Hopper painted rocks along the shore; where his fellow summer artists painted harbor scenes, Hopper headed inland and painted streets in Gloucester's Italian district, railroad crossings and small factories. When he painted boats, as often as not he chose views of their decks and smokestacks, compositions not unlike his scenes of Manhattan rooftops. Architecture, which had seized his fancy when he was in Paris, continued to hold his attention, and beginning in 1923

he painted a gallery of New England houses soon to be known as "Hopper houses": white farm houses, ornate Victorian-gothic piles and relics of the Second Empire style with mansard roofs.

That same year another young artist (and former student of Henri), Josephine Verstille Nivison, persuaded Hopper to submit some of his watercolors to an exhibit at the Brooklyn Museum, and, even more important, she persuaded the Museum to take a look at Hopper's work. The Museum accepted six of Hopper's watercolors for the exhibit, and the critics – at long last – were full of praise (totally ignoring Nivison's own paintings). Hopper was 41, and at long last his career was about to be launched.

The next year, 1924, was something of an *annus mirabilis* for Hopper. In January the Brooklyn Museum bought *The Mansard Roof*, the artist's first sale of a painting since *Sailing*, 11 years earlier at the Armory Show. In July Hopper married Jo Nivison. And in November New York's Frank K. M. Rehn Gallery gave a one-man show of Hopper's watercolors. All 11 watercolors on display – and then five more – sold, and Hopper immediately gave up commercial art, for at last he knew that he would be able to support himself by painting. "Recognition doesn't mean so much," Hopper said years later. "You never get it when you need it." The remark apparently refers to the bitterness he would always feel about the decade when such contemporaries as Burchfield and Bellows were making their names and he was still being ignored. When the National Academy of Design made him an associate member in 1933 Hopper declined the honor because he was still resentful that the Academy had rejected his paintings for exhibition years earlier.

**Opposite:** Like *Night on the El Train*, this 1921 etching, *Evening Wind*, is an early study in urban anomie.

**Right:** The 1922 etching *The Catboat*, an anticipation of such later sailing canvases as *Yawl Riding a Swell* and *The Long leg*.

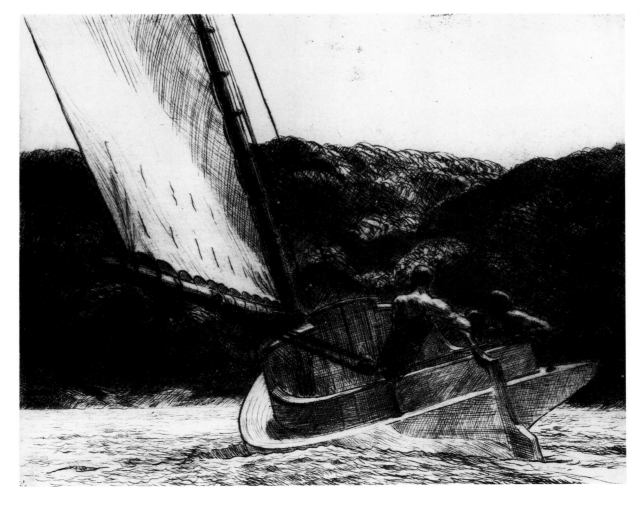

And throughout his career Hopper was more often absent than present at the openings of his many one-man shows. Evidently nothing – not even representing the United States in the Venice Biennale of 1952 or receiving the Gold Medal for Painting of the National Institute of Arts and Letters in 1955 – could make up for the years when he had needed, and not received, recognition.

From 1924 until his death in 1967 at the age of 84, both Hopper's art and life exhibited a remarkable degree of consistency. Hopper and his wife Jo organized their calendar by dividing the year mostly between their fourth-floor walk-up home at 3 Washington Square North in New York, where Hopper had lived since 1913, and the New England seashore. In 1927 Hopper bought a car, but trips farther afield – to South Carolina in 1929, to the far west in 1941 and to Mexico and the southwest in 1951 – were infrequent interruptions of a set routine. On the other hand, having a car did help to open up America for Hopper, though, characteristically, what he chose to paint in his travels was not beauty spots, but roadside gas stations, country motels and railroad crossings. Jo Hopper recollected that her husband was miserable when surrounded by the exotically attractive architecture and landscape of New Mexico and regained his good humor only when he found a locomotive on a railroad siding that seemed a suitable subject for a painting.

From 1934 on the Hoppers spent almost every summer in the house Hopper designed himself in South Truro on Cape Cod. In the house, as in his paintings, Hopper made no concessions to ornament, leaving it spare, white and unadorned. The house was reached by such a wretched track through the sand that locals speculated as to whether it was the Hoppers' parsimony or their misanthropy which led them never to pave the road.

In both their New York and Cape Cod homes the Hoppers led a Spartan existence: friends recalled toiling up the 74 steps of the New York walk-up, only to arrive in a sparsely-furnished studio heated by a coal-stove. For years Hopper carried the coal up all four flights; during the last decade of his life he hauled it up in a dumbwaiter. If a friend were asked to stay for a meal, as often or not it would come straight from a can. Jo Hopper once, not entirely tongue-in-cheek, replied to a request for a recipe for a cookbook on Artists' Favorite Recipes with a note recommending "a can of the friendly baked bean."

In Jo, Hopper found his complement – and seems to have met his match. Jo's political principles were as fiery as Hopper's were conservative. (He returned early from the Cape in 1940 in order to vote for Wilkie against Roosevelt.) They were a contrast in almost every way: Jo was as petite as her husband (almost six feet five inches) was tall, and she as volatile and talkative as he was steady and taciturn. As Jo once remarked, "sometimes talking with Eddie is just like dropping a stone in a well, except that it doesn't thump when it hits bottom." Inevitably, there were those who said that Jo Hopper talked so much that Edward Hopper had no need to, and some found her more shrewish than scintillating, but all agreed that she was indispensable to her husband.

**Above:** A conte sketch of Jo Hopper, the artist's wife, made sometime in the years between 1935 and 1940.

**Opposite:** The link between *Evening Wind* of 1921 and this famous canvas, *Morning Sun* (1952), is clear.

If Jo Hopper never subordinated her personality to that of her husband, she did, however, yield her career to his. She insisted that she serve as the model for every woman Hopper drew, which meant both an end to Hopper's attendance of the evening sketch classes at the Whitney Studio Club and many fewer hours for Jo to do her own painting. The woman in *Girlie Show*, the women in *Western Motel* and both women in *Second Story Sunlight* were Jo. As the years went on, whereas Hopper's preliminary sketches showed Jo with the slackening body of a woman "of a certain age", she was often transformed in the final painting into a more youthful figure, such as the usherette in *New York Movie*.

Although Jo never stopped painting, much of her energy went into cosseting Hopper. Soon after the marriage Jo began to keep the day books recording Hopper's work. As his reputation grew she became Hopper's watchdog: anyone who wanted an interview had to get past Jo, and often she sat in on – and talked through – the interview itself. Once, as critic Brian O'Doherty was attempting to get Hopper's thoughts on the art market, Jo leaned forward and confided to O'Doherty, "I once bit him to the bone. I felt the bone under my teeth. Next day *he* was bragging about it." It was clearly a complicated relationship: in one cartoon, Hopper showed himself as a saint, labeled "Non-Anger Man," while Jo was portrayed with claws, and

labeled "Pro-Anger Woman." Their fights were, apparently, memorable.

"I'm a self-seeker," said Hopper who, somewhat surprisingly, held that "What lives in a painting is the personality of the painter . . . The man's the work. Something doesn't come out of nothing." He claimed that he was annoyed when people assumed that his personality must be a lonely, alienated and pessimistic as his work, and he protested that "the loneliness thing is overdone." Yet Hopper's reclusive lifestyle, his own silences and the sense of forbidding silence implied in most of his paintings (Charles Burchfield spoke of Hopper's painting as "silent poetry") inevitably suggest the image of a bleak personality. Hopper knew this perfectly well, and, denials notwithstanding, he was comfortable with this image and went to some lengths to foster it.

As John Updike said of Hopper in *Just Looking: Essays on Art,* Americans like a bit of the "hermit crab" in their painters. And not only their painters: Hopper's reclusiveness and self-conscious lack of affectation remind one of Robert Frost. Not surprisingly, Frost was Hopper's favorite poet, and, like Frost, he consciously developed his persona as a flinty and somewhat mysterious individualist. When Hopper was interviewed to a *Time* magazine cover story in 1956 he warned his sister Marion to tell the interviewer "absolutely nothing about me or our family." If he were really so jealous of his privacy, we can only wonder why he agreed to let the story run in the first place.

Like Frost, Hopper was heaped with honors in the last decade of his life. Since his death in 1967 the Whitney Museum, to which Jo Hopper left their joint collection of paintings, has mounted several important retrospectives. Although Hopper's rigorous realism has had few disciples (Andrew Wyeth has admitted being influenced by Hopper), his reputation is, if anything, more secure today than when he died in 1967.

In 1933 the Museum of Modern Art gave Hopper his first retrospective, and what critic Albert Barr wrote then in the catalogue still holds true: "The story of Edward Hopper abounds in curious anomalies. He is now famous but for twenty years his career as an artist was obscure to the point of mystery. He is now famous as a painter but he first won wide recognition as an etcher. He is now famous as a painter of landscape and architecture but his student years were devoted exclusively to figure painting and illustration. He is now famous as a painter of emphatically American landscape and architecture, but the landscape and architecture which first interested him were French. It is surprising that his art, having survived such reversals, should now appear so personal, so sure and consistent." Personal, sure, and consistent: the words sum up Hopper as well as words can, but words can only go so far. As Hopper said of his life and work, "The whole answer is there on the canvas."

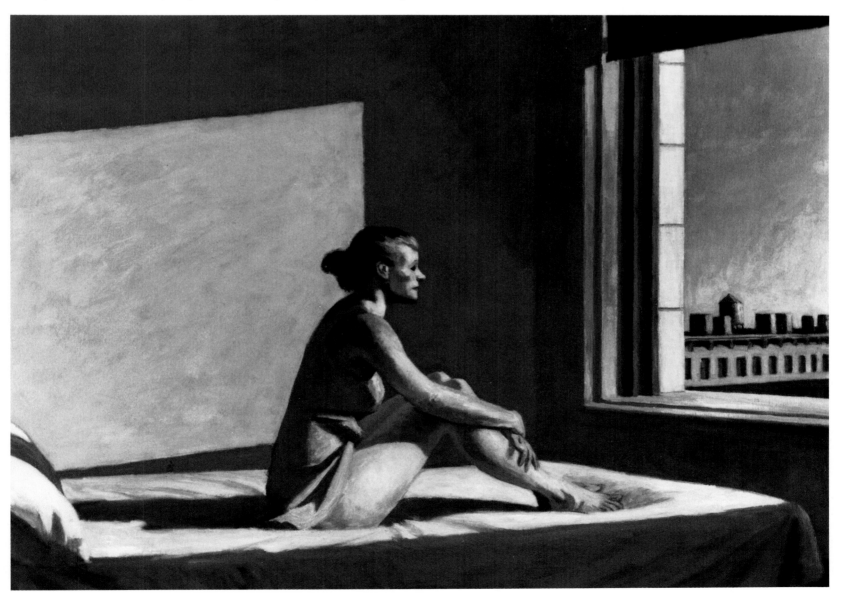

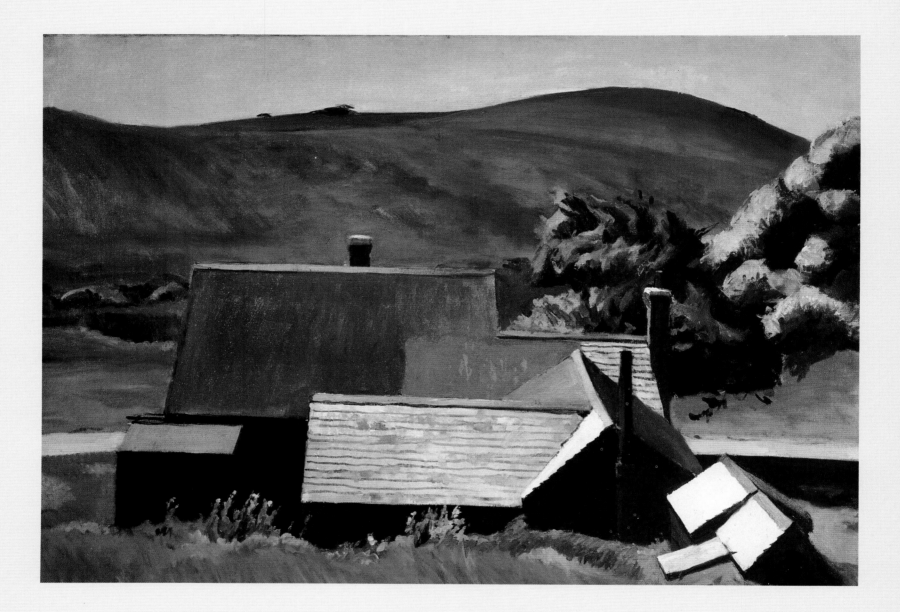

**Burly Cobb's House, South Truro**
1930-33, oil on canvas, 24¾×36 in.
*Bequest of Josephine N. Hopper,*
*Collection of Whitney Museum of American*
*Art, New York, NY*
(70.1210)

# NATURAL SETTINGS

In the summer of 1923 Hopper abandoned the French scenes which had dominated his etchings and early paintings and began an extraordinary series of watercolors of Cape Ann. At last he had "gotten over Europe," and had found the subject of his mature painting – what Lloyd Goodrich called "The physical face of the United States, in city, town, and country." As early as 1927 Goodrich could say, "It is hard to think of another painter who is getting more of the quality of America in his canvasses than Edward Hopper." Inevitably, some critics placed Hopper beside Grant Wood and Thomas Hart Benton in the "American scene" movement. Hopper himself disagreed, once saying, "I think the American Scene painters caricatured America. I always wanted to do myself."

Surely it is Hopper's focus on "doing himself" that gives his paintings, whatever the scene, an unexpected unity of mood. The ostensible subject may be a *Yawl Riding a Swell,* a *Lighthouse Hill,* the coastal landscapes of *Hills, South Truro* and *The Camel's Hump* or the mysterious *Rooms by the Sea,* but the real subject is Hopper's perception of his subject and the way in which light defines that subject. This is true whether it is the light striking the side of a lighthouse, flooding the sails of a yawl at sea or infusing the hills of Cape Cod with the sense of ocean just beyond the hills.

Hopper's friend and fellow artist Guy Pène du Bois was much impressed by the simple power of *Hills, South Truro.* "It shows a railroad track, a very incidental house, and a range of hills behind," he wrote. "Its order, measure, and proportion, to revert to the Greek term, give it a simple and profound majesty and with that sense of never going beyond the truth." Typically, Hopper said of the painting simply that "the mosquitoes were terrible" the day he painted it.

A painter is sometimes as interesting for what he does not paint as for what he does. Hopper had little interest in portraying the seasons (no autumn foliage) or different kinds of weather (no snowstorms). He once said that it took him years before he could bring himself to paint a cloud, and Hopper's clouds are as unobtrusive as clouds can be. With the exception of a few sea gulls and the collie in *Cape Cod Evening* (1936), there are no animals in Hopper. Nor do his landscapes include flowers; the only flowers Hopper could remember painting were those in the vase in *Room in Brooklyn.* Throughout, his palette was consistent, his colors bold and seldom shaded, and he almost never experimented with "painterly" brush work and texture.

In *Rooms by the Sea* Hopper's emphasis is not on the sea, but on the geometric shapes made by the rooms and by the light streaming into them. Like *Room in Brooklyn,* it shares with some of the distinctive "Hopper Houses" – *Cobbs' Barn and Distant Houses,* for instance, and *Ryder's House* – a sense of the geometry of forms that has led some to see Hopper as more of an abstract artist than he did himself. It was probably *Rooms by the Sea* that Pop artist Jim Dine had in mind when he said that Hopper was "more exciting than Magritte as a surrealist." On occasion Hopper included figures in his scenes of natural settings, as in *Cape Cod Morning* and *Cape Cod Evening,* but the figures are not the painting's central focus. When Hopper's wife Jo once suggested that the woman looking out of bay window in *Cape Cod Morning* was checking to see if the weather was good enough to hang out her wash, Hopper accused her of trying to turn his painting into something "out of Norman Rockwell."

Both Hopper and Jo remarked that *Cape Cod Evening* was almost called *Whippoorwill,* after the unseen bird the dog is straining to hear. In both *Cape Cod Morning* and *Cape Cod Evening,* in fact, the focus is on something out of sight. Both houses are unsettling, with lawns gone to seed, both are framed (almost threatened) by encroaching groves of locust trees and both speak to what John Updike has called Hopper's "interest in the thoughtful light at the edges of the day."

**Lighthouse Hill**
1927, oil on canvas, 28¼×39½ in.
*Gift of Mr. and Mrs. Maurice Purnell,*
*Dallas Museum of Art, TX*
(1958.9)

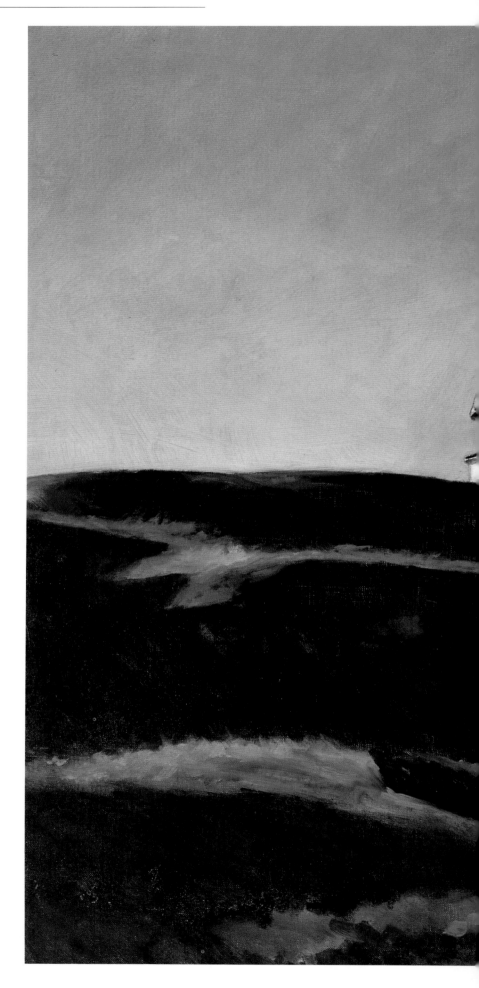

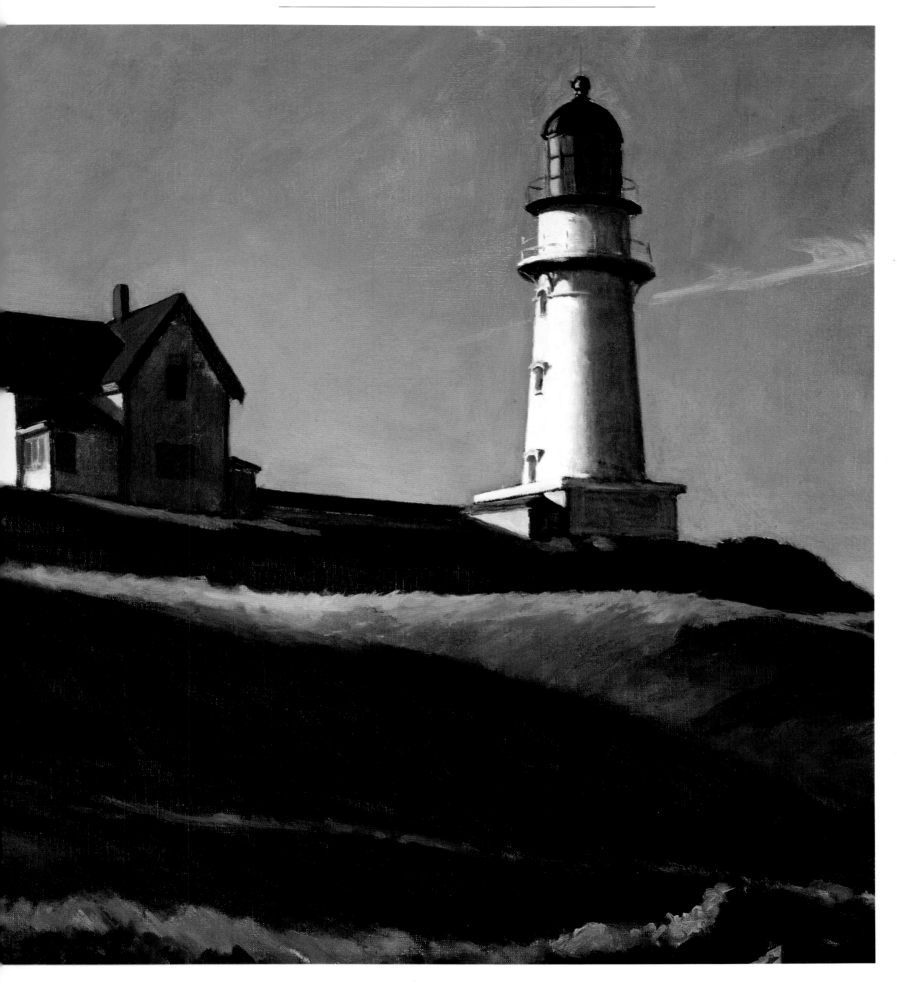

**Yawl Riding a Swell**
1935, watercolor over graphite on off-white wove paper, 19⅞×27¾ in.
*Worcester Art Museum, MA*
(1935.145)

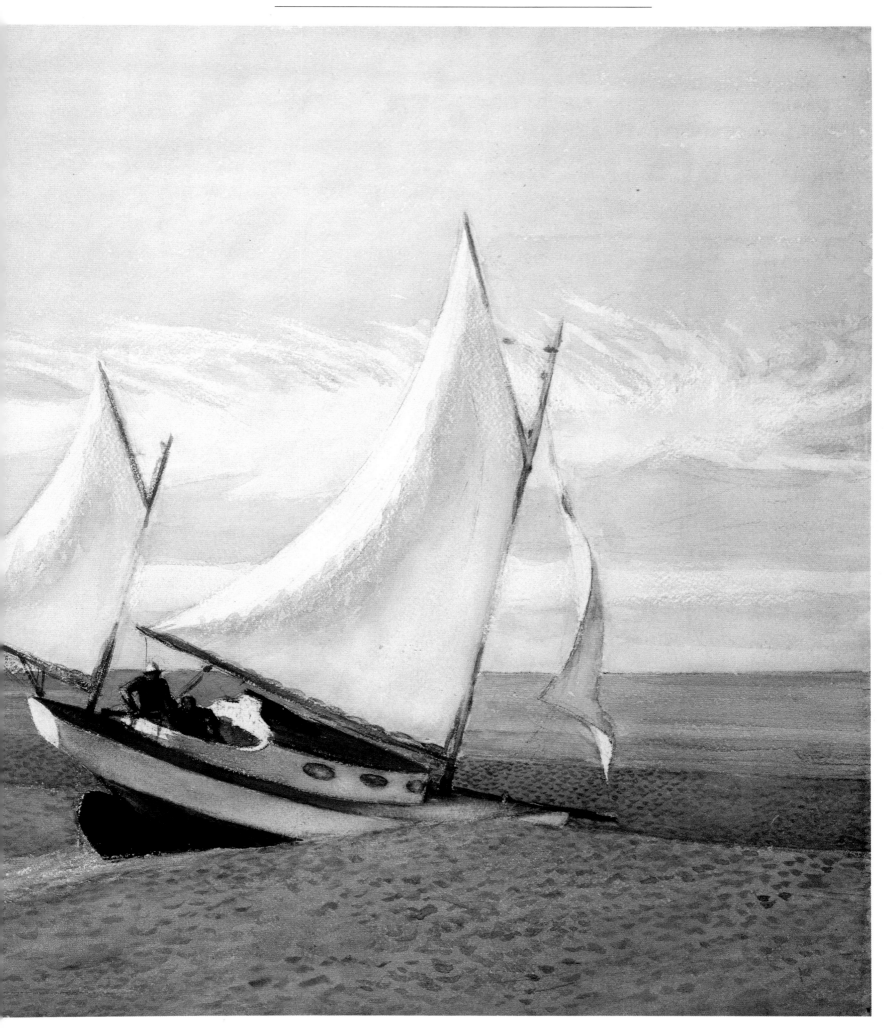

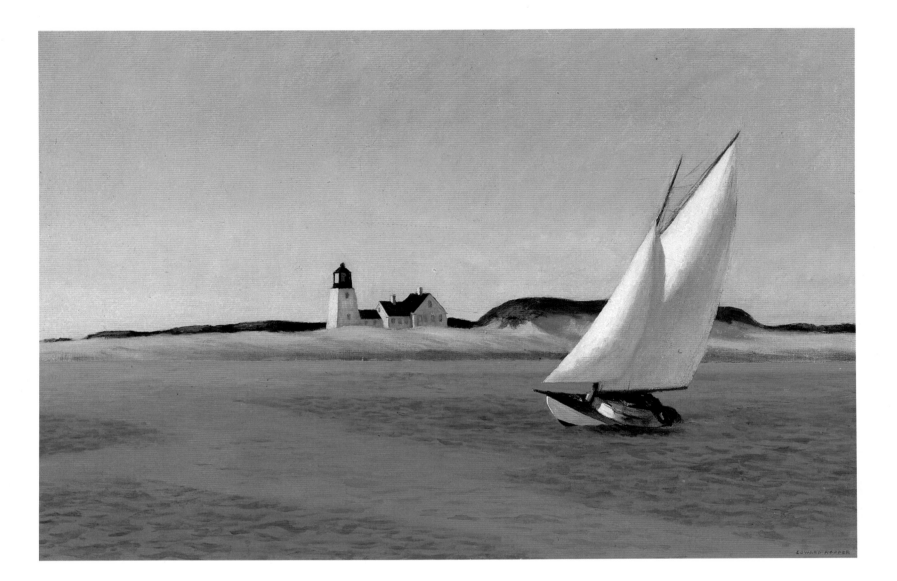

**The Long Leg**
1935, oil on canvas, 20×30¼ in.
*Virginia Steele Scott Foundation,*
*The Huntington Library and Art Gallery,*
*San Marino, CA*

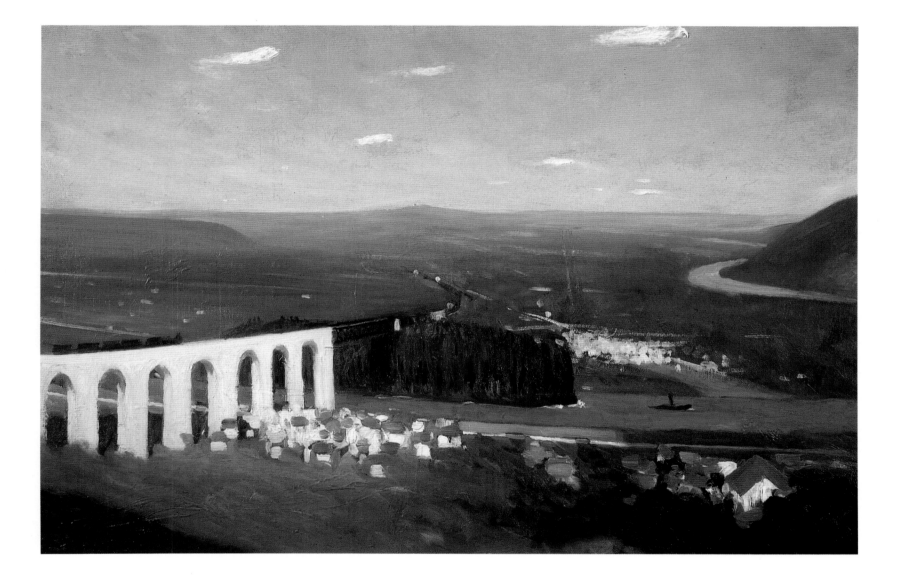

**Valley of the Seine**
1908, oil on canvas, 26×28 in.
*Bequest of Josephine N. Hopper,*
*Collection of Whitney Museum of American*
*Art, New York, NY*
(70.1183)

Pages 26-27:
**Cape Cod Afternoon**
1936, oil on canvas, 34×50 in.
*Patrons Art Fund, 1938,*
*The Carnegie Museum of Art, Pittsburgh,*
*PA*
(38.2)

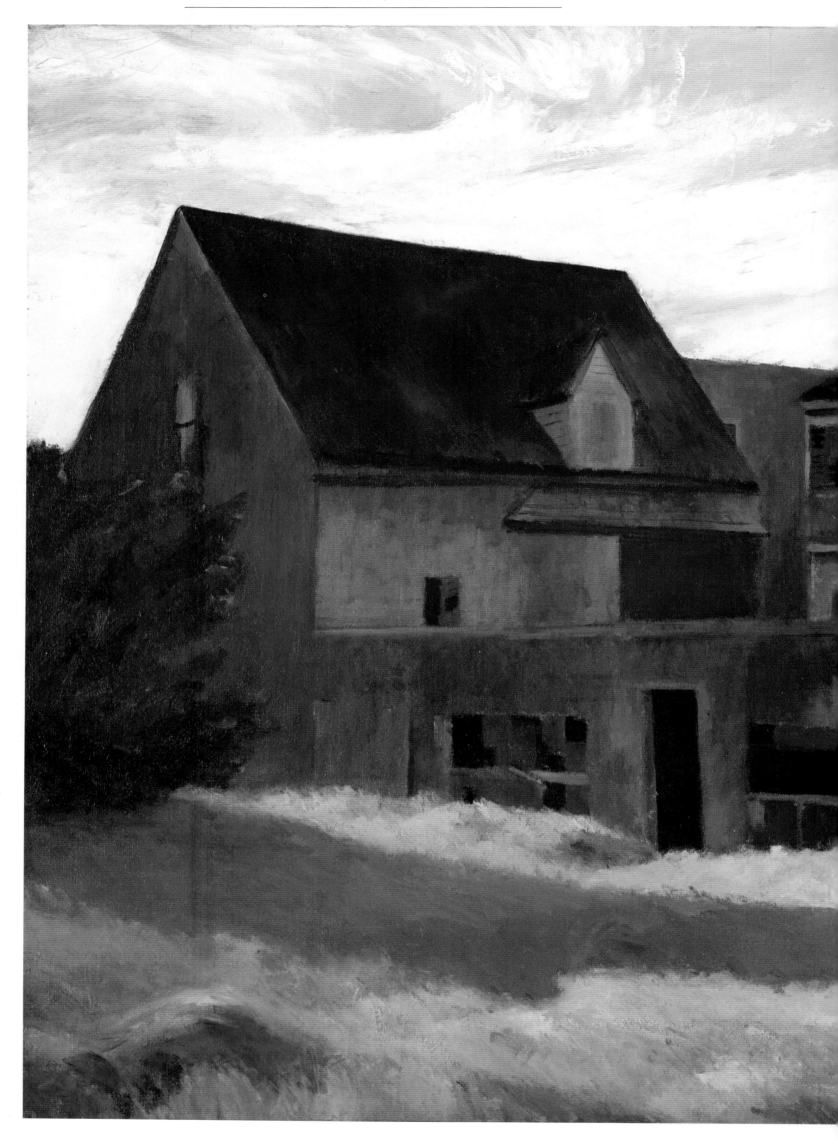

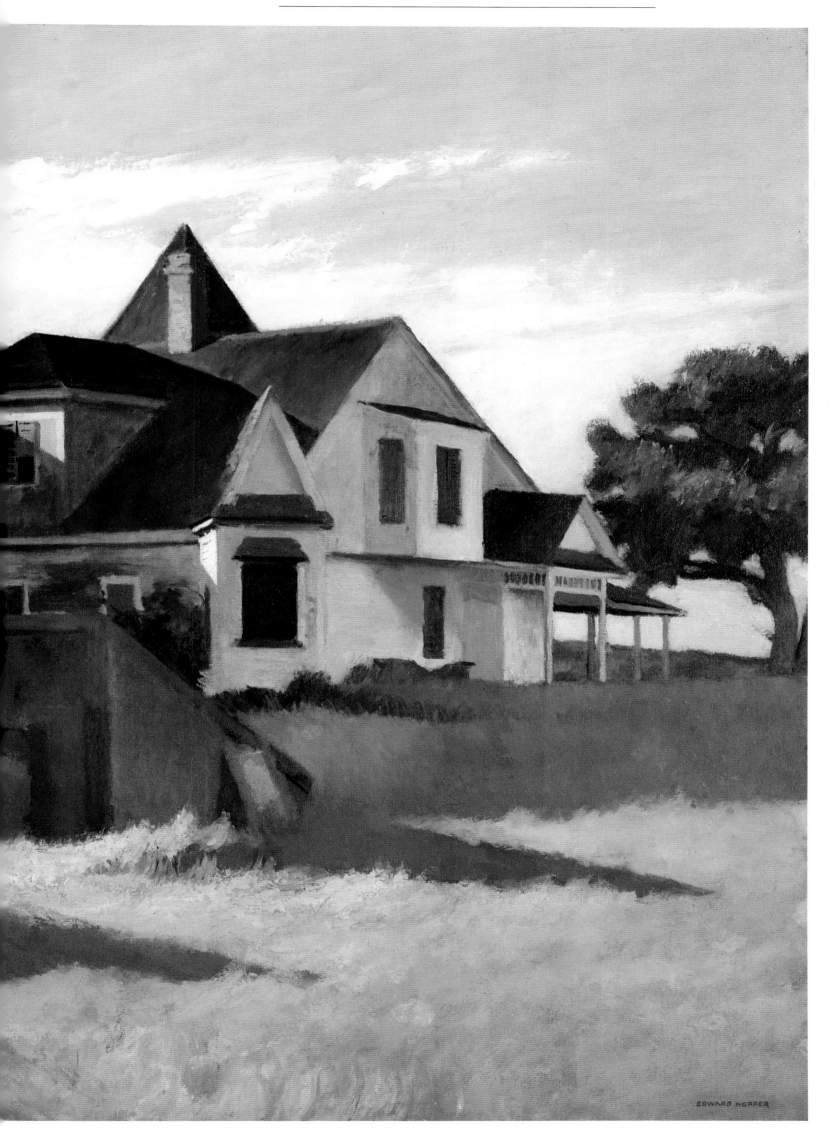

**Cape Cod Evening**
1939, oil on canvas, 30¼×40¼ in.
*John Hay Whitney Collection,*
*National Gallery of Art, Washington, DC*
(1982.76.6)

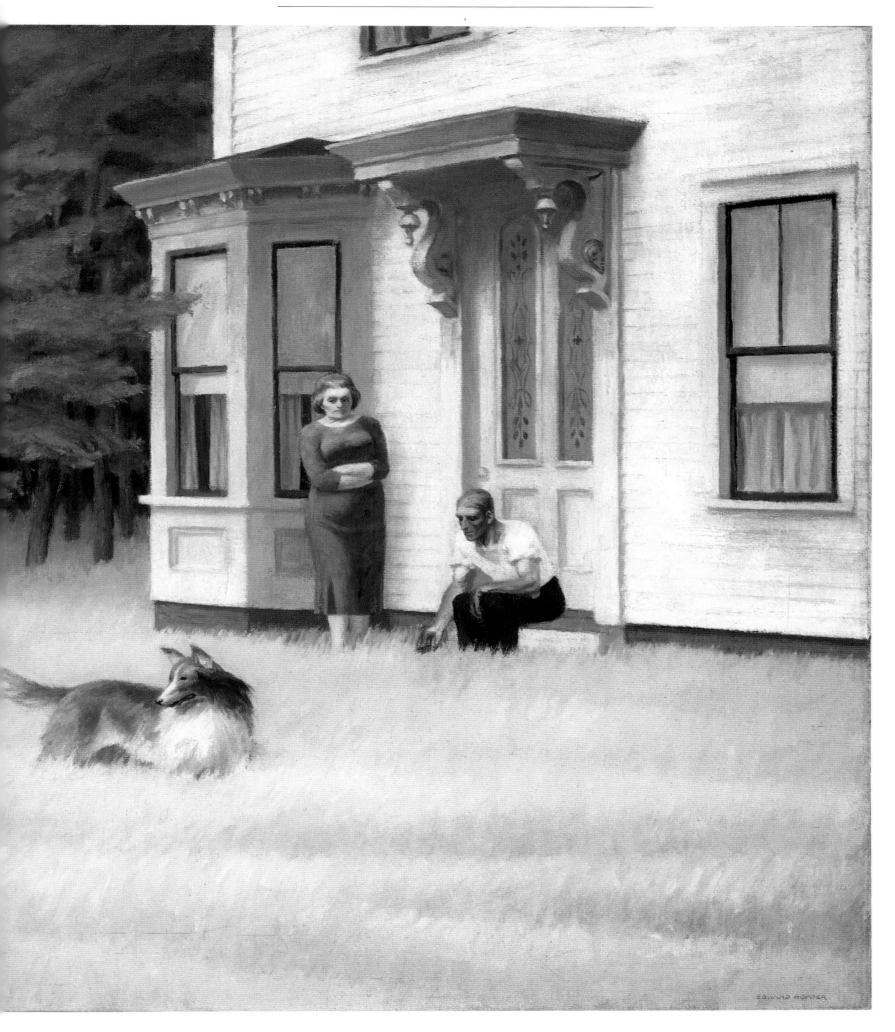

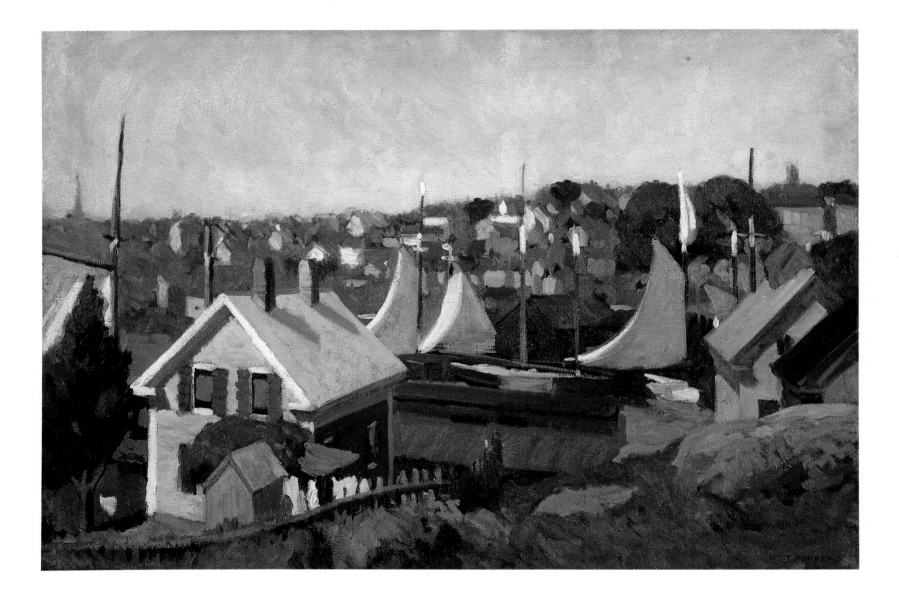

**Gloucester Harbor**
1912, oil on canvas, 26×28 in.
*Bequest of Josephine N. Hopper,*
*Collection of Whitney Museum of American*
*Art, New York, NY*
(70.1204)

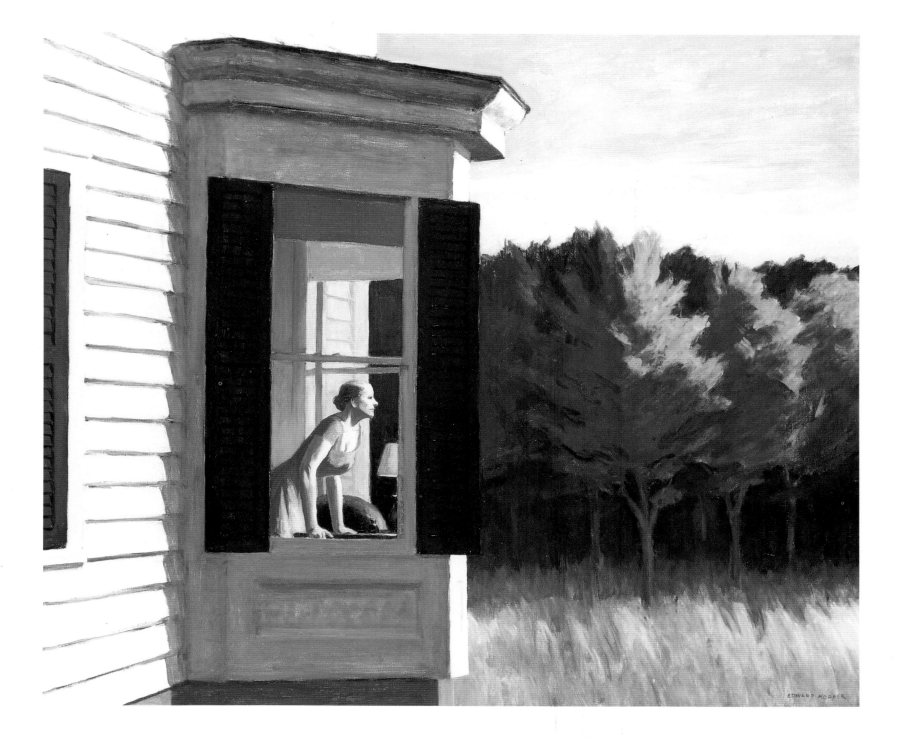

**Cape Cod Morning**
1950, oil on canvas, 34¼×40⅛ in.
*Gift of the Sara Roby Foundation,*
*National Museum of American Art,*
*Smithsonian Institution, Washington, DC*
(1986.6.92)

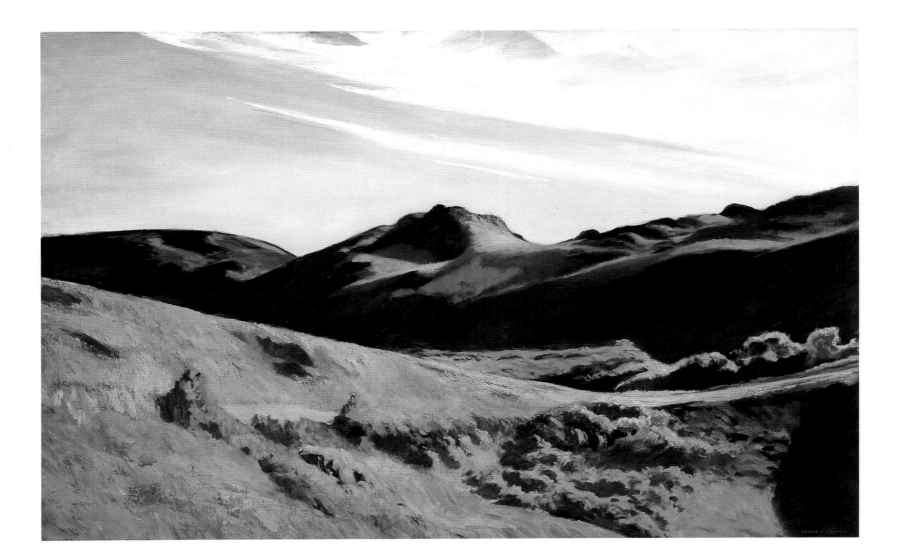

**The Camel's Hump**
1931, oil on canvas, 32¼×50⅛ in.
*Bequest of Edward W. Root,*
*Munson-Williams-Proctor Institute Museum*
*of Art, Utica, NY*
(57.160)

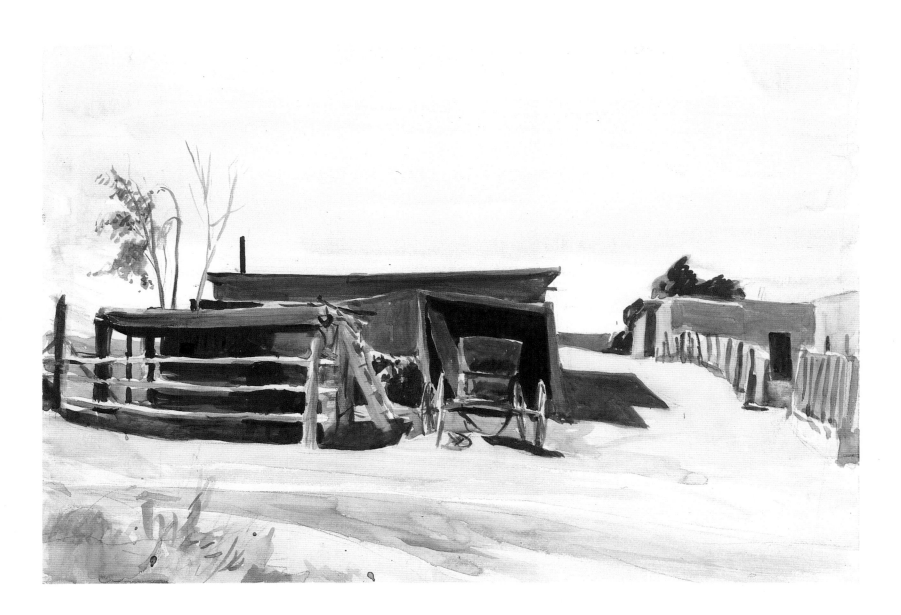

**Adobes and Shed, New Mexico**
1925, watercolor on paper, 13⅞×19¹⁵⁄₁₆ in.
*Bequest of Josephine N. Hopper,*
*Collection of Whitney Museum of American*
*Art, New York, NY*
(70.1121)

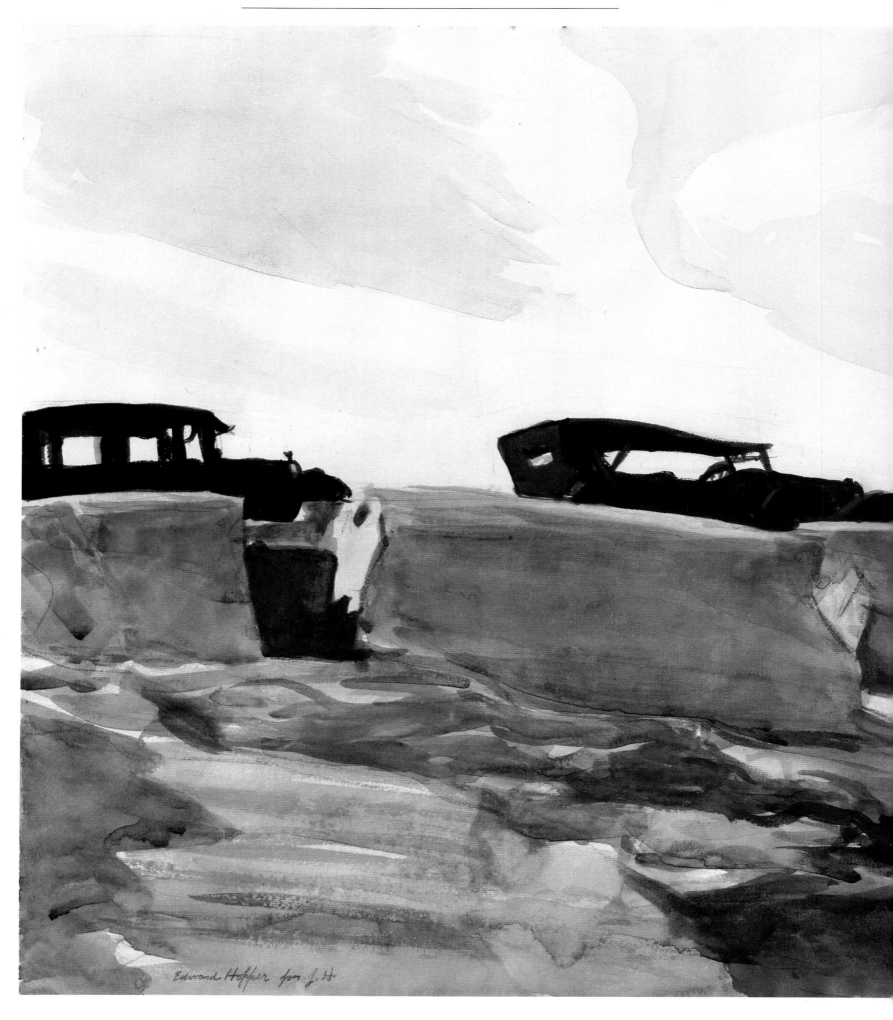

Edward Hopper for J. H.

**Cars and Rocks**
1927, watercolor on paper, 13⅞×20 in.
*Bequest of Josephine N. Hopper,*
*Collection of Whitney Museum of American*
*Art, New York, NY*
(70.1104)

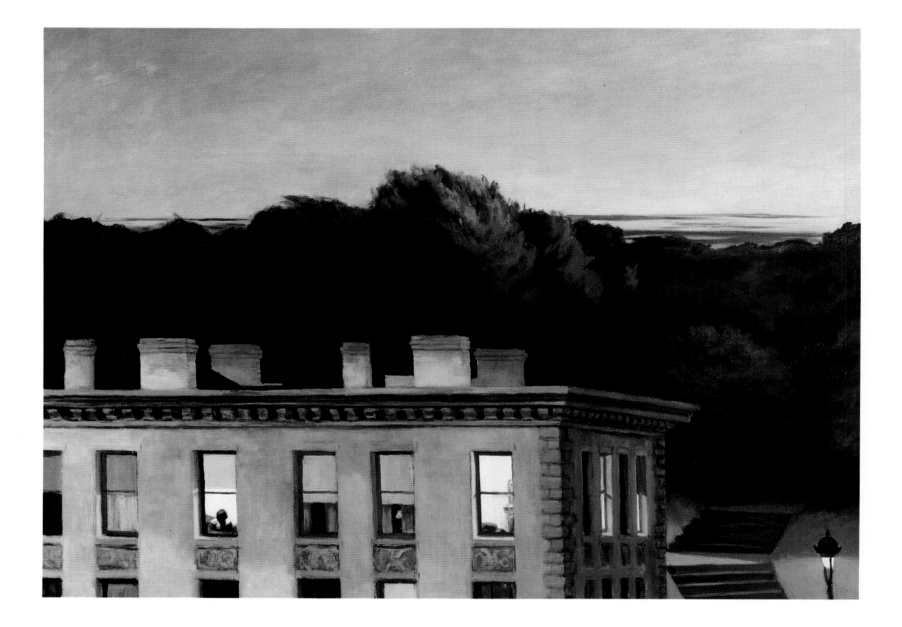

**House at Dusk**
1935, oil on canvas, 36½×50 in.
*The John Barton Payne Fund,*
*Virginia Museum of Fine Arts, Richmond,*
*VA*
(53.8)

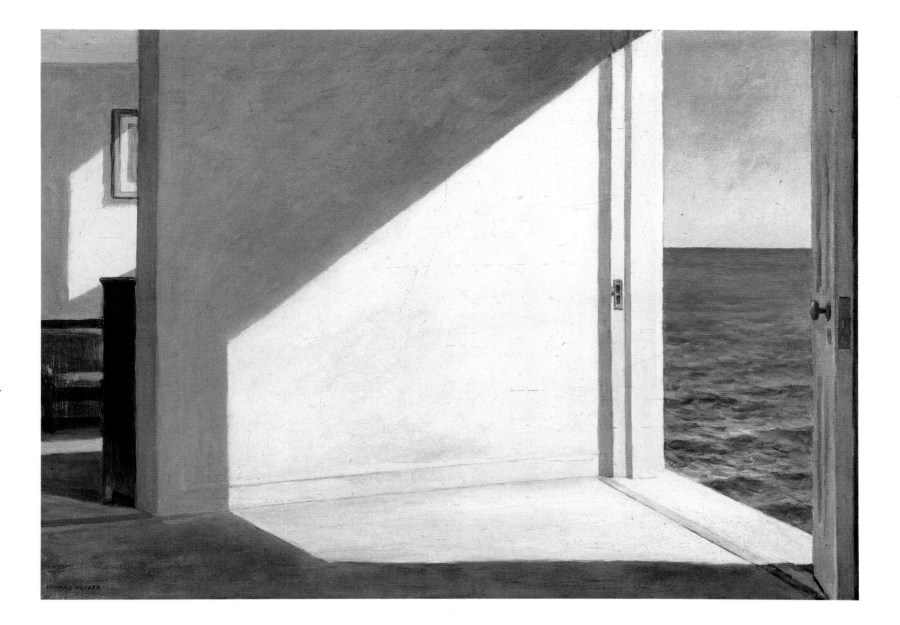

**Rooms by the Sea**
1951, oil on canvas, 29×40⅛ in.
*Bequest of Stephen Carlton Clark,*
*Yale University Art Gallery, New Haven,*
*CT*
(1961.18.29)

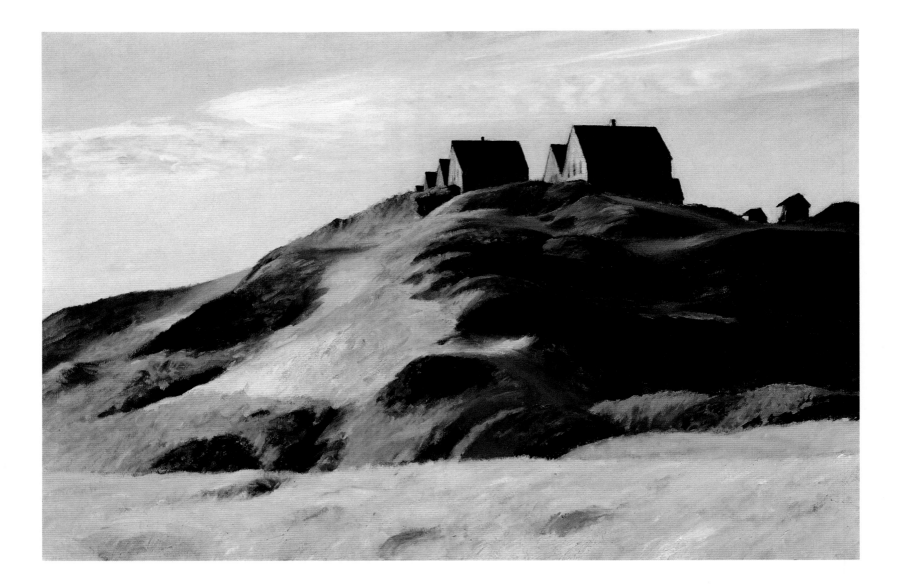

**Corn Hill (Truro, Cape Cod)**
1930, oil on canvas, 28½×42½ in.
*The Mary and Sylvan Lang Collection,*
*Marion Koogler McNay Art Museum, San*
*Antonio, TX*

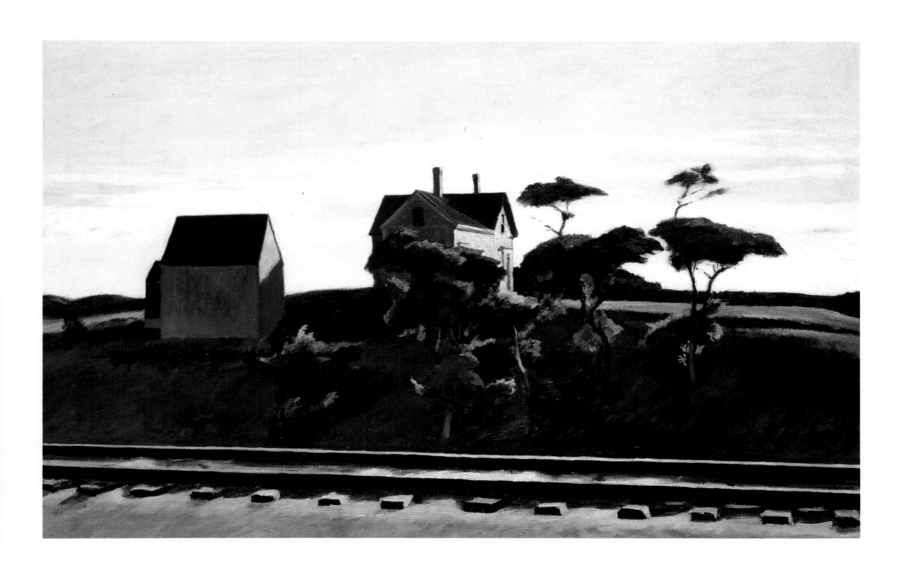

**New York, New Haven and Hartford**
1931, oil on canvas, 32×50 in.
*Emma Harter Sweetser,*
© *1989 Indianapolis Museum of Art, IN*
*(32.177)*

Pages 40-41:
**Railroad Sunset**
1929, oil on canvas, 28¼×47¾ in.
*Bequest of Josephine N. Hopper,*
*Collection of Whitney Museum of*
*American Art, New York, NY*
*(70.1104)*

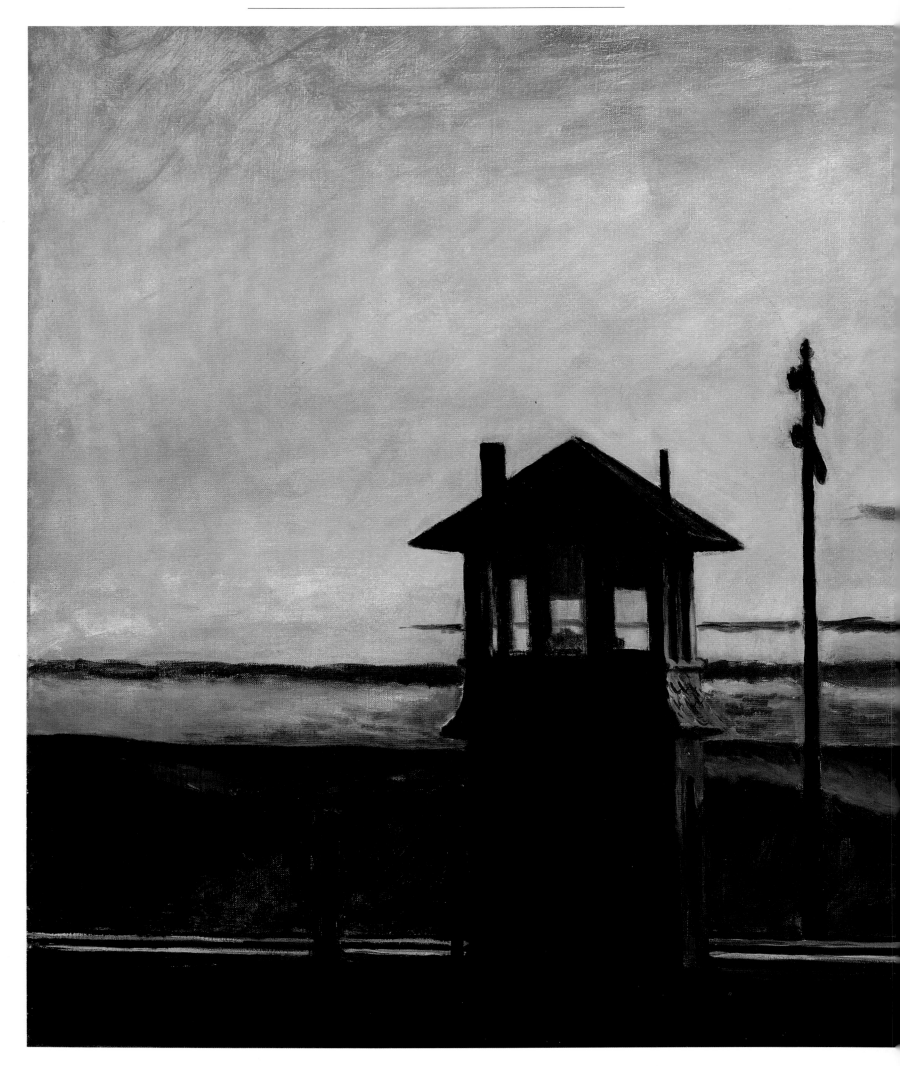

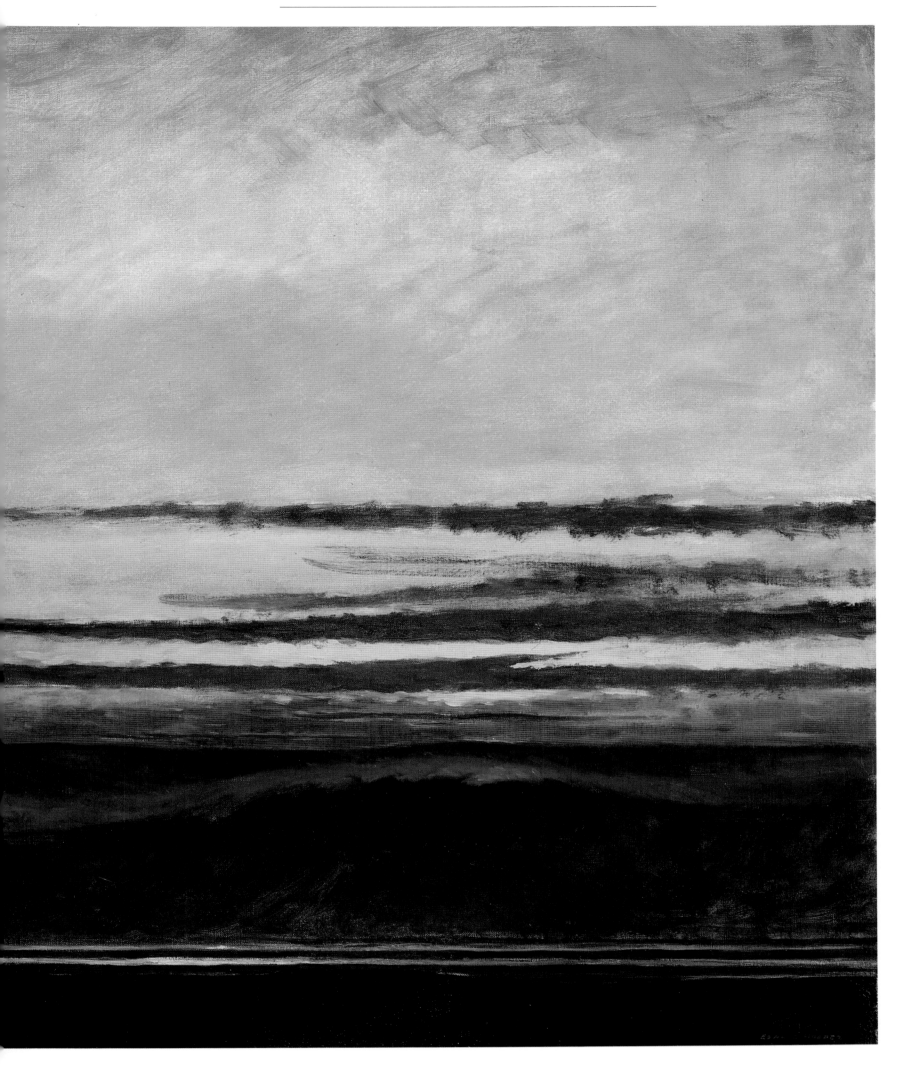

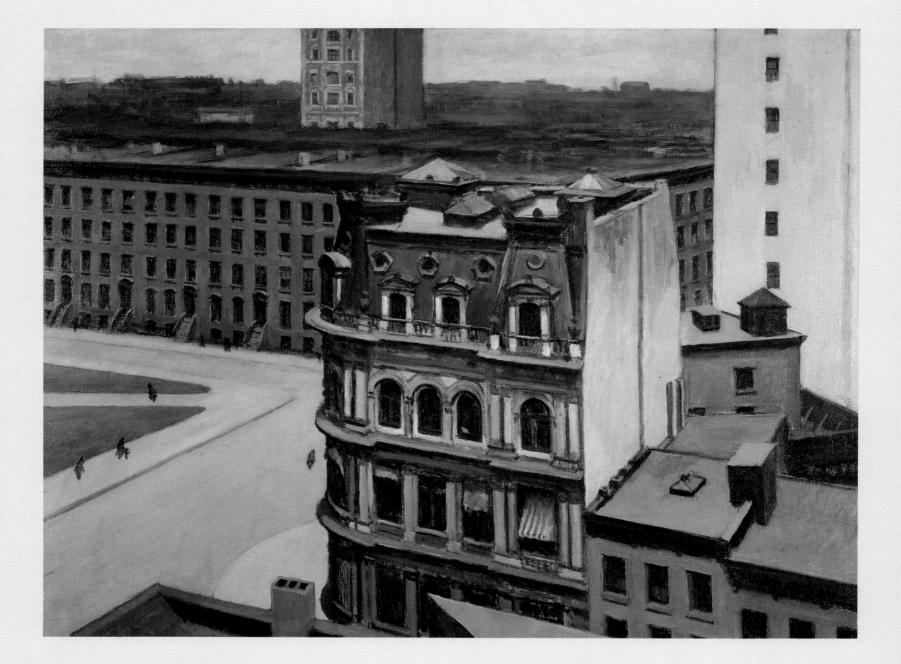

**The City**
1927, oil on canvas, 27½×37 in.
*Gift of C. Leonard Pfeiffer,*
*Collection of the University of Arizona*
*Museum of Art, Tucson, AZ*

# CITIES, TOWNS AND COUNTRY ROADS

One of Hopper's first loves was architecture, and a number of early paintings, such as *The Louvre in a Thunderstorm*, suggest how the great buildings of Paris captivated the young painter. However, once Hopper began to "get over" Europe and focus on America, his eyes were opened to the poetry of familiar American places. Even when he painted an isolated rural scene, as in *House by the Railroad*, his love of architecture was obvious. Hopper delighted in the variety of what he described as "our native architecture, with its hideous beauty, its fantastic roofs, pseudo-Gothic, French Mansard, Colonial, mongrel, or what not."

Hopper recalled that he painted *The Mansard Roof* in Gloucester, Massachusetts, in "the residential district where the old sea captains had their houses . . . It interested me because of the variety of roofs and windows, the Mansard roof, which has always interested me . . . I sat out on the street . . . it was very windy." Twenty-two years later, when he painted *Rooms for Tourists*, Hopper was more self-conscious about sitting down to paint in front of someone's house. Instead, night after night, to get the light right, he sat painting in his car across from the tourist home, worried, he recalled, that the owners would wonder why a stranger was watching their house and would call the police.

Members of The Ash Can School, such as Hopper's teacher, Robert Henri, as well as John Sloan and George Bellows, had used the city as a background in their paintings. Hopper made the urban setting itself the important thing. In some of his earliest paintings, such as *American Village* and *Yonkers* and *Summer Street*, people are shown as tiny, insignificant, almost irelevant figures. In both paintings the focus is unmistakably on the buildings, not the people. Significantly, Hopper painted out the figures he included in his first version of *Early Sunday Morning*, and in so doing he created a cityscape not unlike those Walker Evans was photographing in the 1930s.

*Early Sunday Morning* and *Drug Store* seem to present a city devoid of life; the window in *Drug Store* is as barren as the street in *Early Sunday Morning*. In these paintings, as well as in *Approaching a City* and *Seven A.M.*, there is what some critics have called a "listening quality", a pervasive silence. This silence is as characteristic of all Hopper's work as his use of light, and Hopper's silences are perhaps most felt in those of his paintings that do focus on the human figure.

Oddly, Hopper almost never showed the most distinctive feature of the twentieth-century American city, the skyscraper. He limited himself to the one truncated skyscraper in *The City*, a painting that shows his love of strong diagonals in composition. Mark Rothko once said, "I hate diagonals, but I like Hopper's diagonals. They're the only ones I like."

While Joseph Stella and Georgia O'Keeffe were painting New York as glamorous and showing its skyscrapers as modern cathedrals, Hopper painted a city that was neither elegant nor seductive. In Manhattan critic Alfred Barr once eavesdropped on a conversation between Hopper and an unidentified painter. Said the painter, "Look! What a wonderful composition those skyscrapers make, what light, what massing. Look at them, Hopper! "And Hopper replied, "Anything will make a good composition."

Hopper's contemporary, Charles Burchfield, also painted urban scenes, although his forte was small-town life, a less-frequent topic for Hopper. Hopper wrote an appreciation of Burchfield (whom he admired) which many critics think is one of the best analyses not only of Burchfield, but of Hopper himself. "By sympathy with the particular," Hopper wrote, "he has made it epic and universal. No mood has been so mean as to seem unworthy of interpretation; the look of an asphalt road as it lies in the broiling sun at noon, cars and locomotives lying in God-forsaken railway yards, the steaming summer rain that can fill us with such hopeless boredom . . . all the sweltering, tawdry life of the American small town, and behind all, the sad desolation of our suburban landscape."

**Tugboat at Boulevard Saint Michel**
1907, oil on canvas, 25¾×28⅝ in.
*Bequest of Josephine N. Hopper,*
*Collection of Whitney Museum of*
*American Art, New York, NY*
(70.1250)

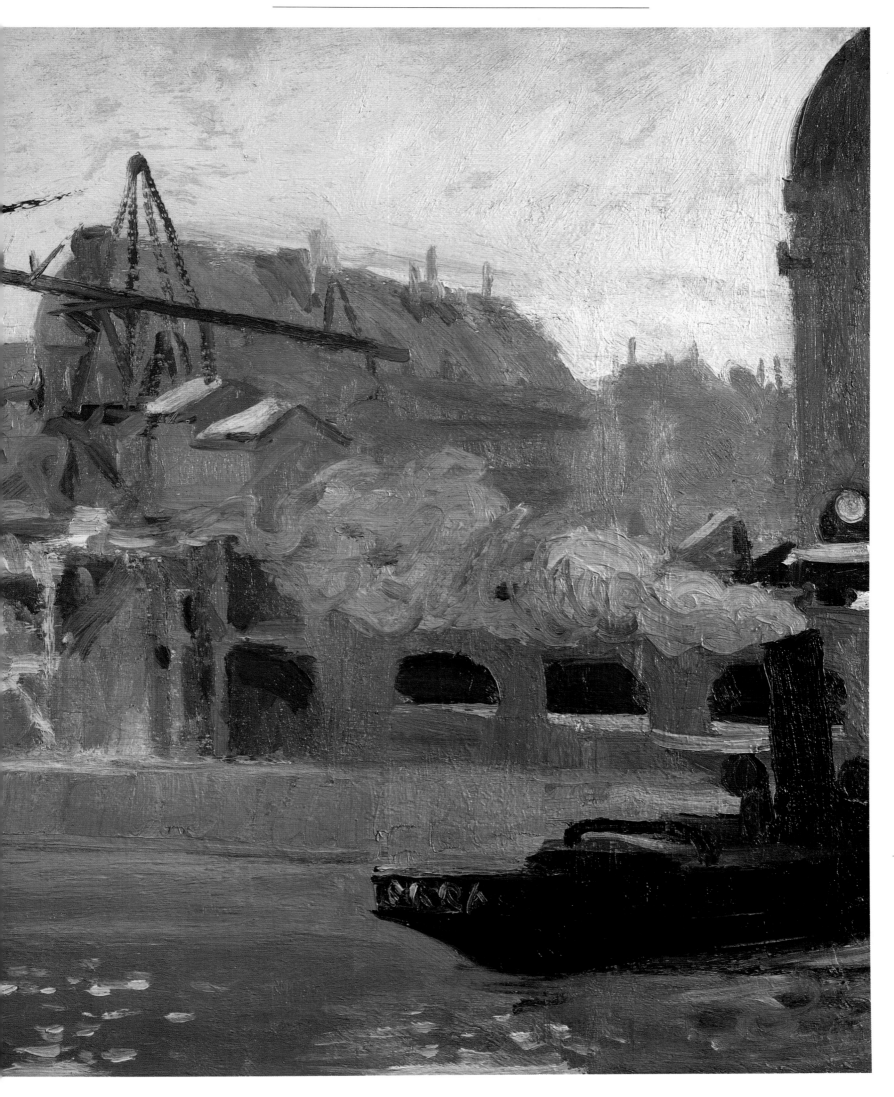

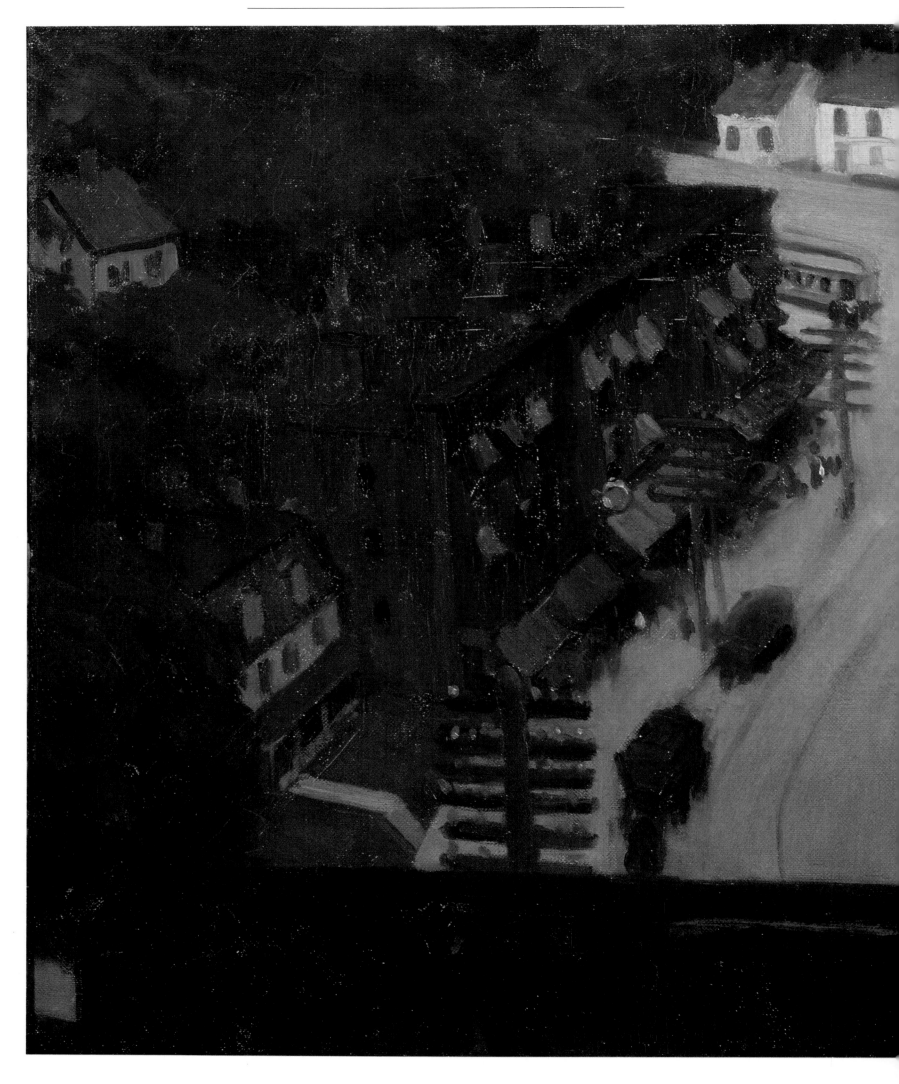

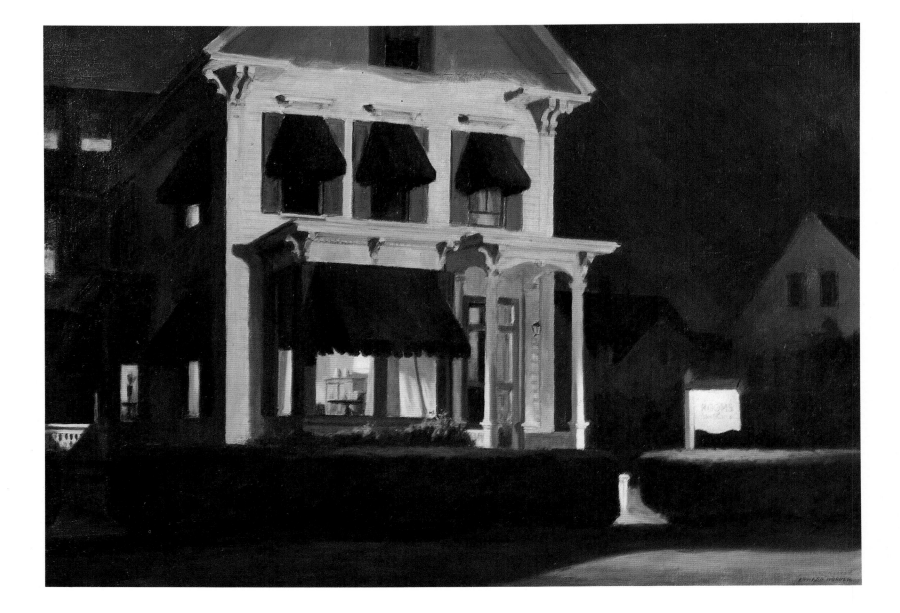

Pages 46-47:
**American Village**
1912, oil on canvas, 26×38 in.
*Bequest of Josephine N. Hopper,*
*Collection of Whitney Museum of*
*American Art, New York, NY*
(70.1185)

**Rooms for Tourists**
1945, oil on canvas, 30¼×42⅛ in.
*Bequest of Stephen Carlton Clark,*
*Yale University Art Gallery, New Haven,*
*CT*
(1961.18.30)

**Seven A.M.**
1948, oil on canvas, 30×40 in.
*Purchase and exchange,*
*Collection of Whitney Museum of*
*American Art, New York, NY*
*(50.8)*

Pages 50-51:
**The Mansard Roof**
1923, watercolor over pencil, 14×20 in.
*Museum Collection Fund,*
*The Brooklyn Museum, NY*
*(23.100)*

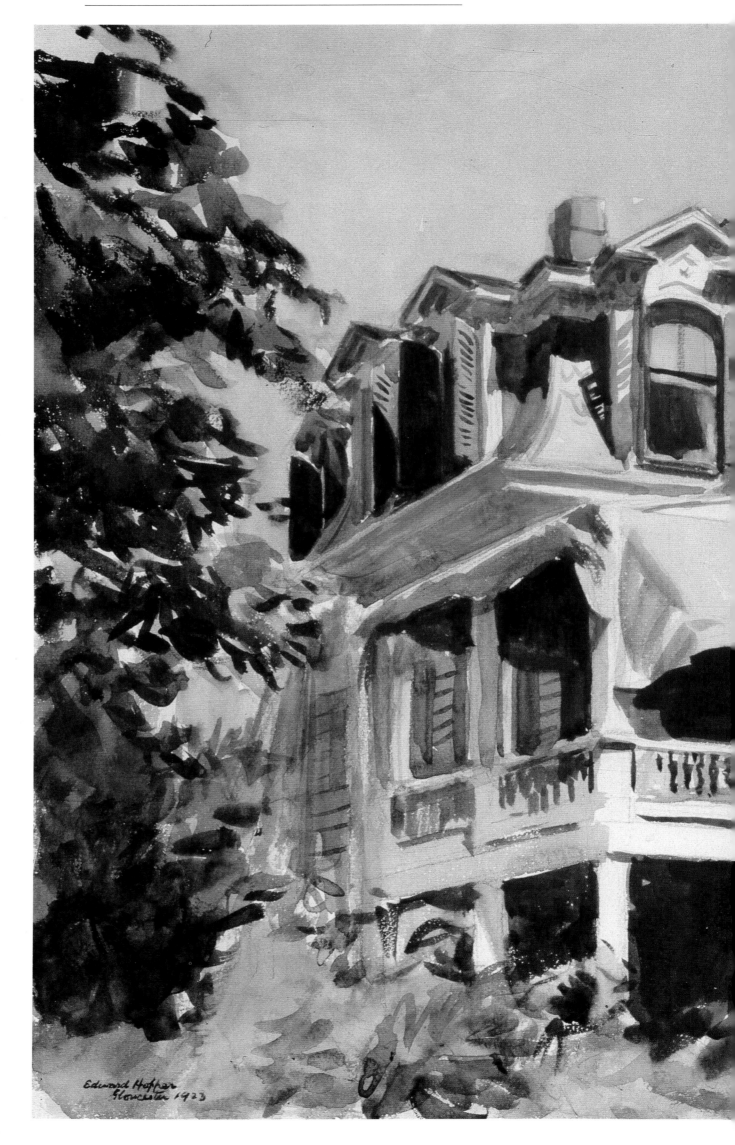

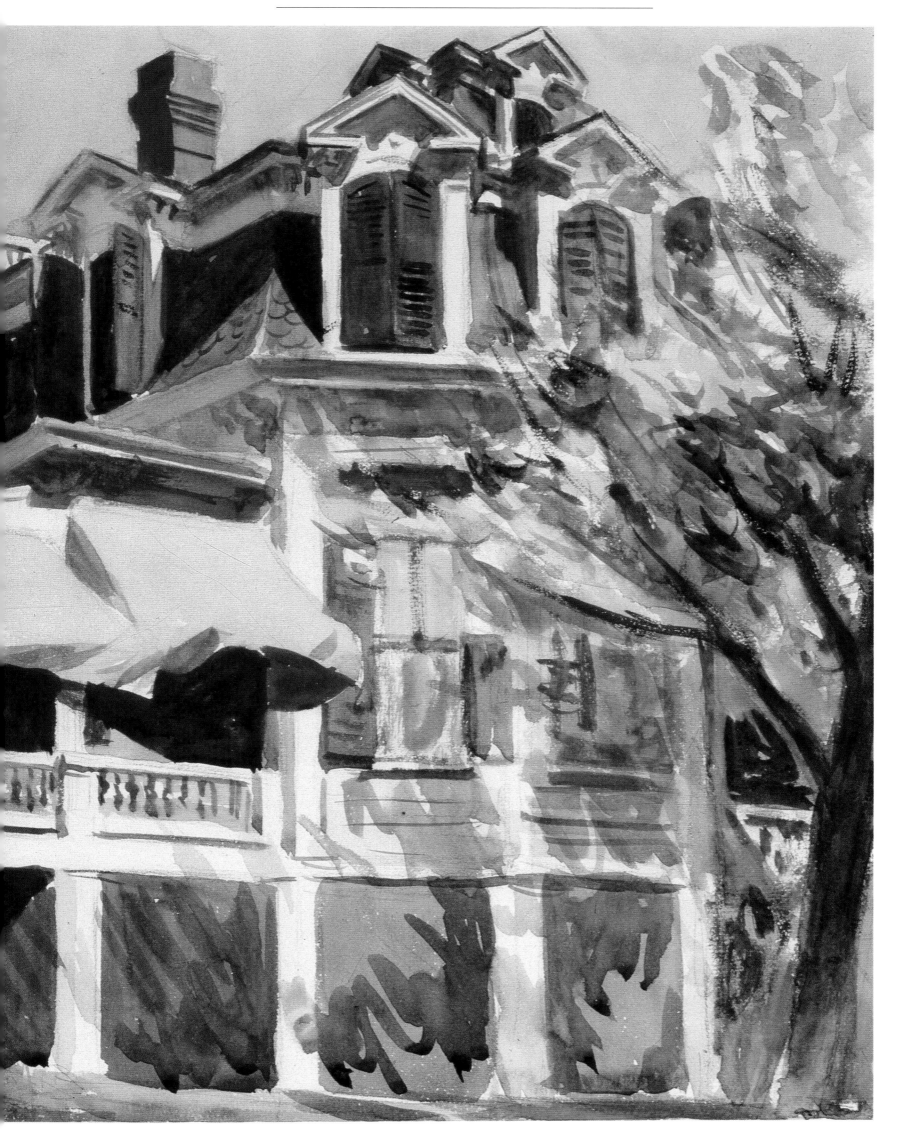

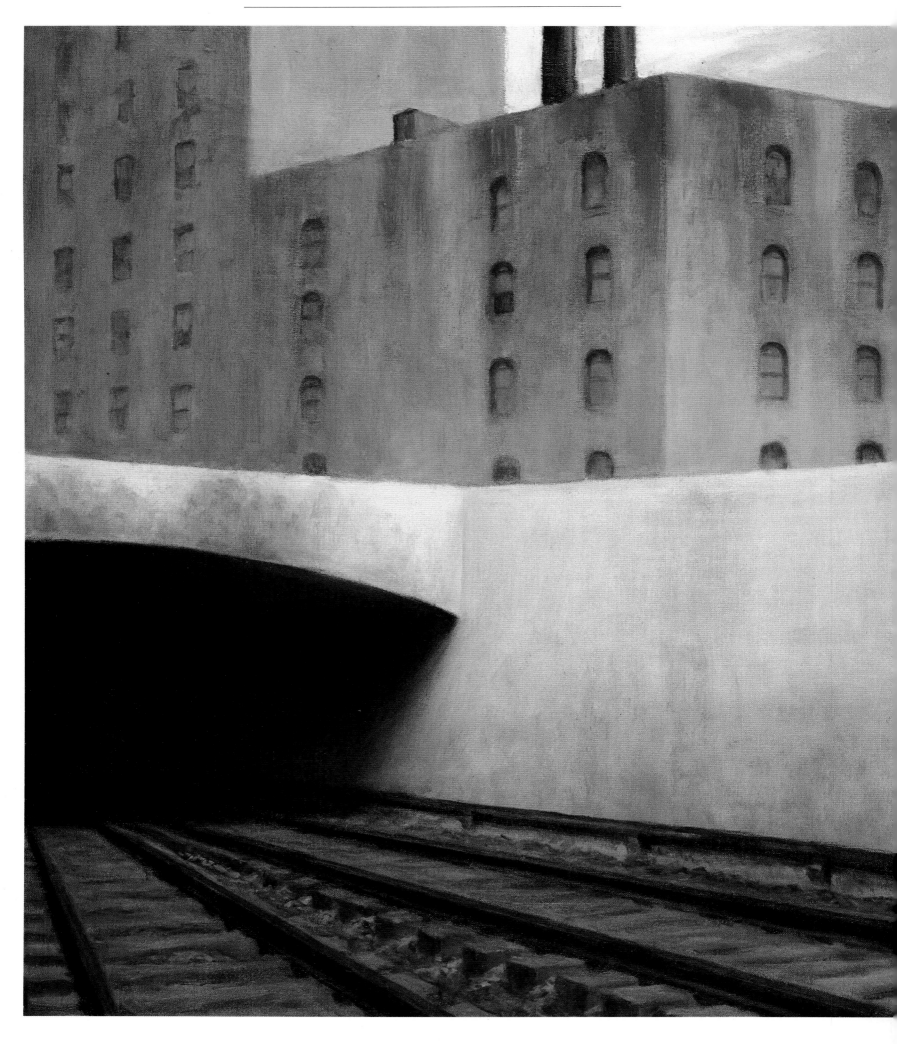

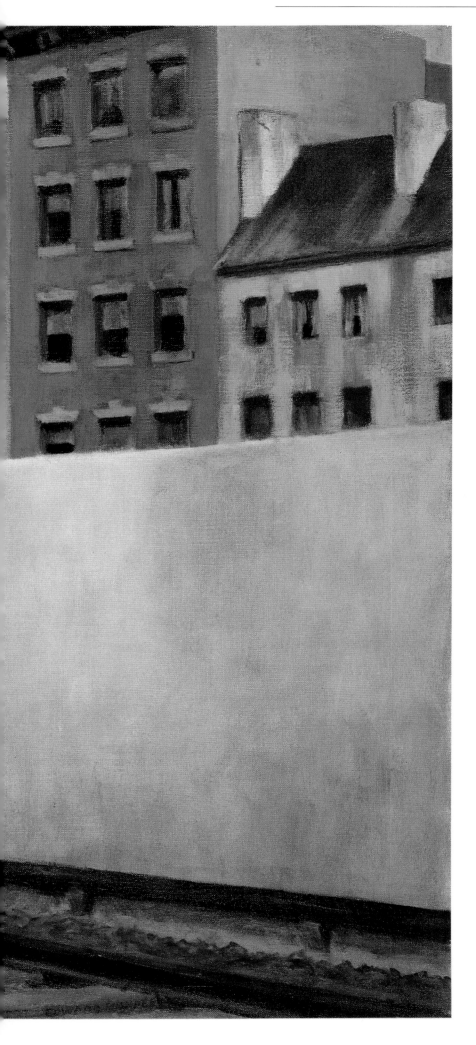

**Approaching a City**
1946, oil on canvas, 27⅛×36 in.
*The Phillips Collection, Washington, DC*

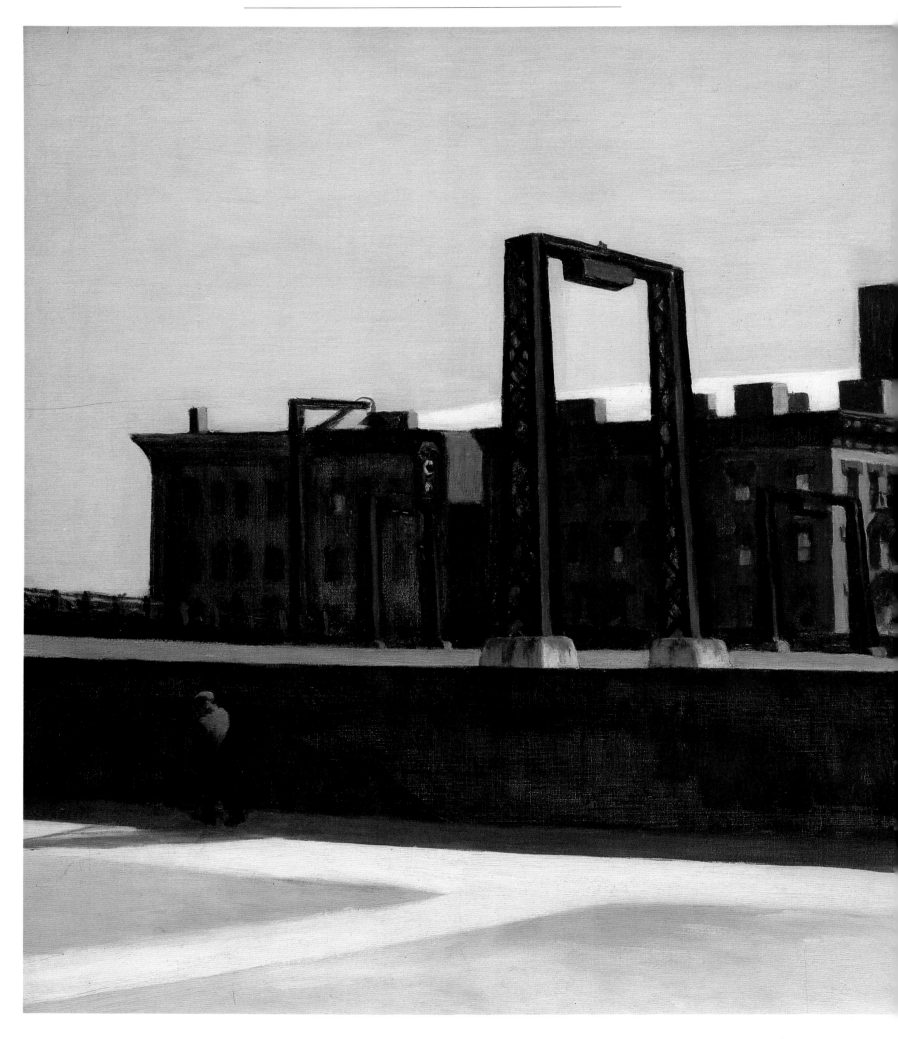

**Manhattan Bridge Loop**
1928, oil on canvas, 35×60 in.
*Gift of Stephen C. Clark*
*Addison Gallery of American Art, Phillips*
*Academy, Andover, MA*

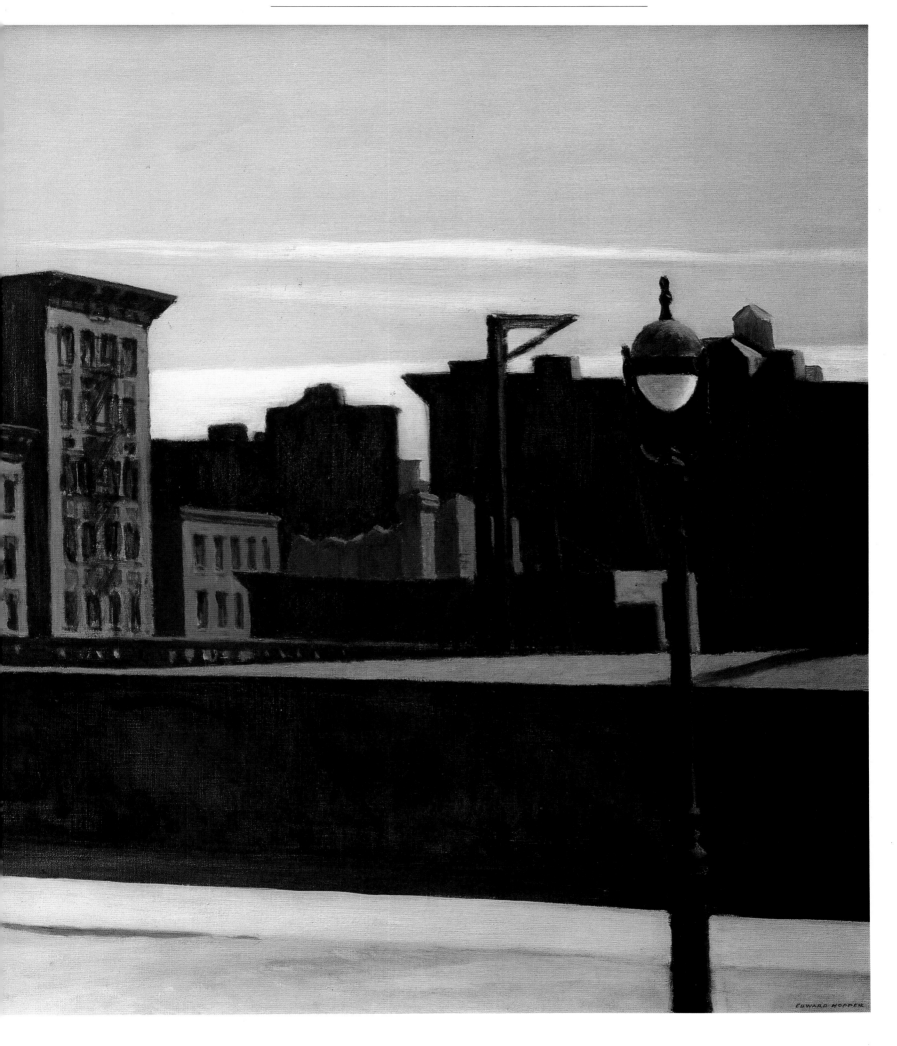

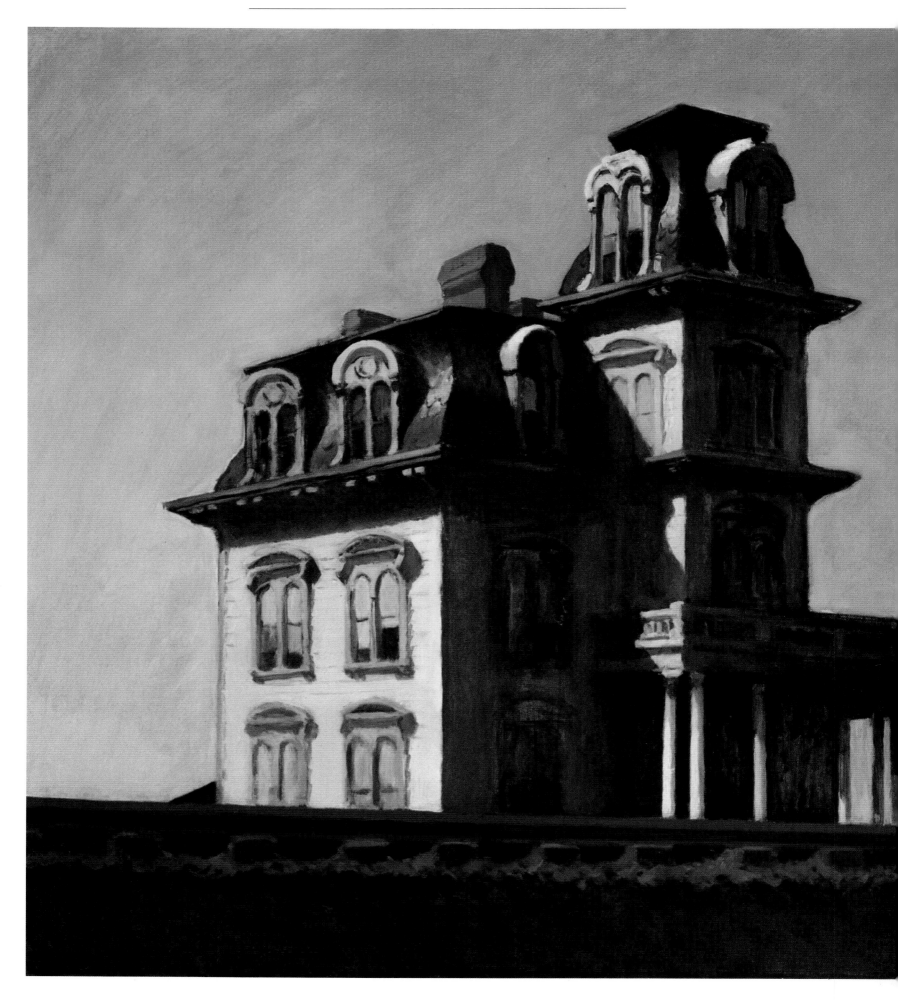

**House by the Railroad**
1925, oil on canvas, 24×29 in.
*Given anonymously,*
*Collection, The Museum of Modern Art,*
*New York, NY*

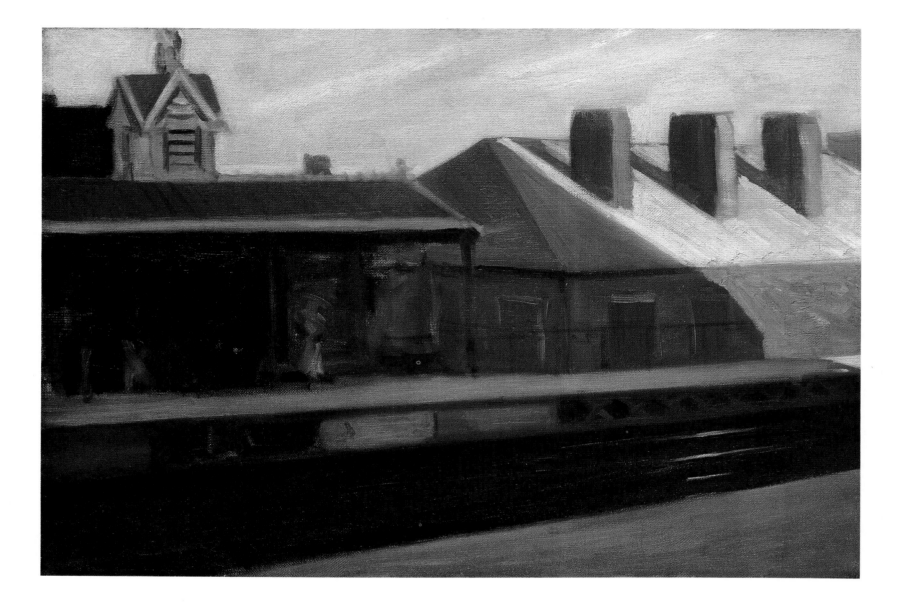

**The El Station**
1908, oil on canvas, 20×29 in.
*Bequest of Josephine N. Hopper,*
*Collection of Whitney Museum of*
*American Art, New York, NY*
(70.1182)

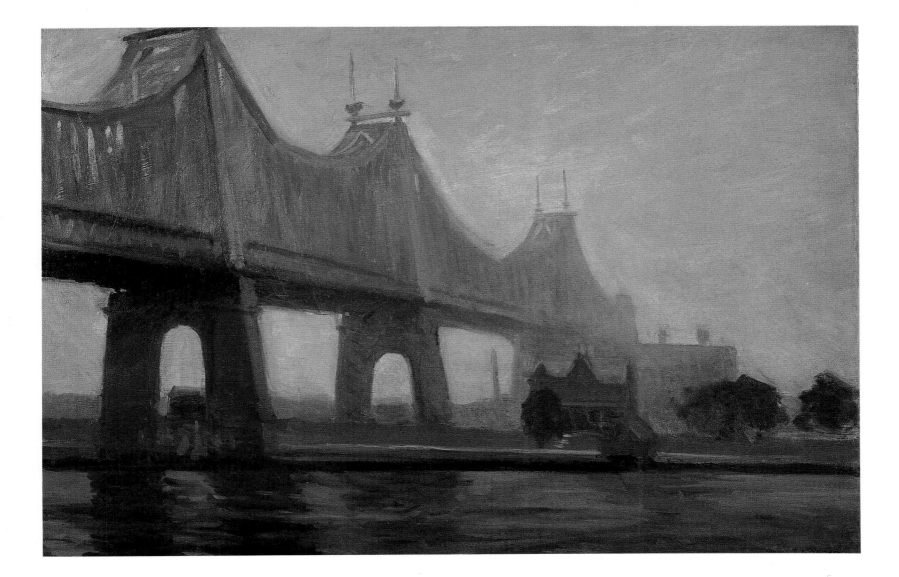

**Queensborough Bridge**
1913, oil on canvas, 35×60 in.
*Bequest of Josephine N. Hopper,*
*Whitney Museum of American Art,*
*New York, NY*
(70.1184)

**Yonkers**
1916, oil on canvas, 24×29 in.
*Bequest of Josephine N. Hopper,*
*Whitney Museum of American Art, New*
*York, NY*
(70.1215)

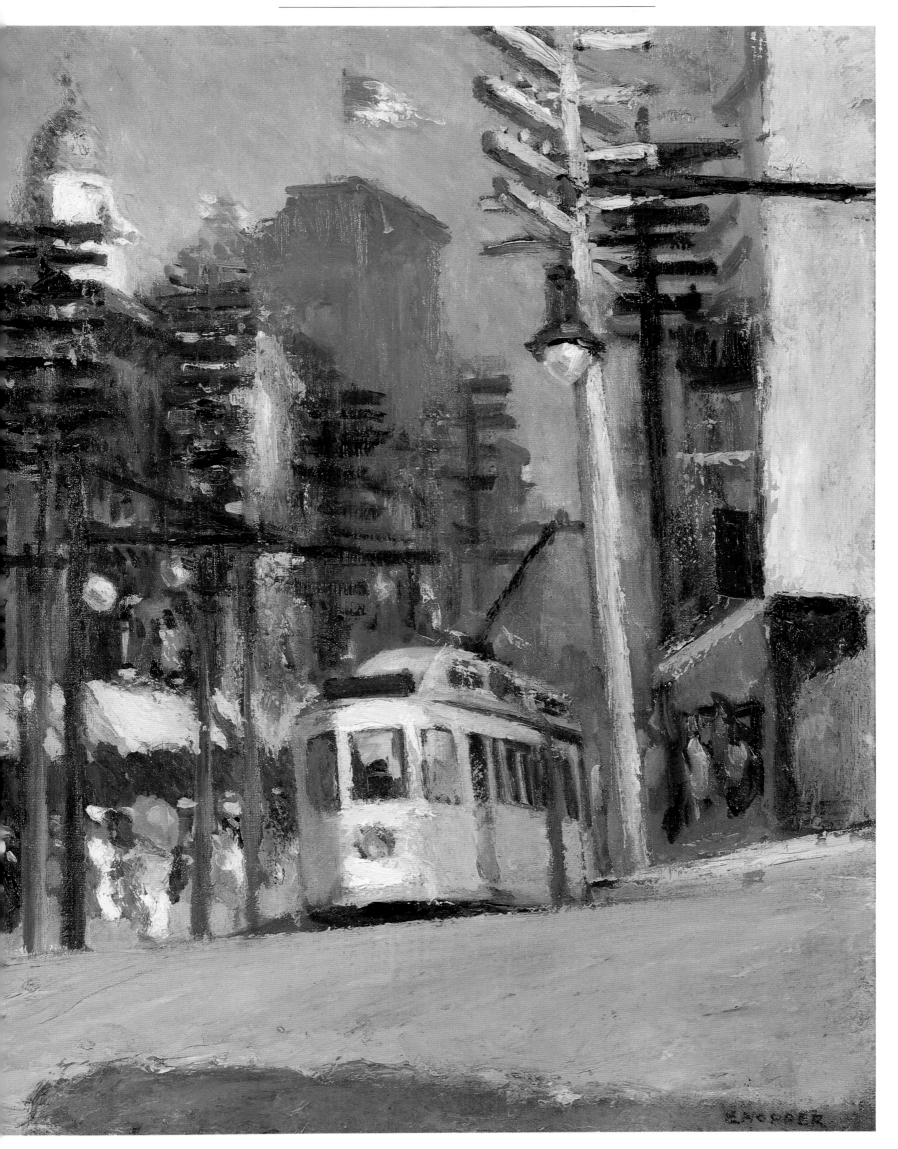

**Drug Store**
1927, oil on canvas, 29×40 in.
*Bequest of John T. Spalding,*
*Courtesy of Museum of Fine Arts,*
*Boston, MA*
(48.564)

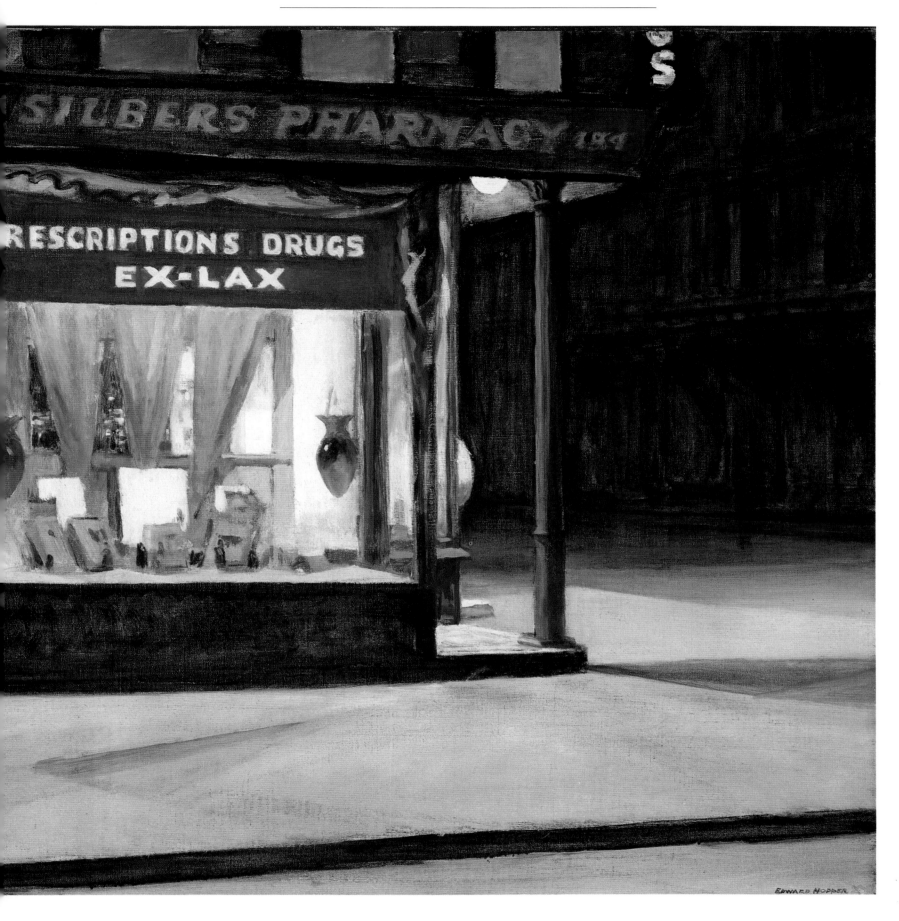

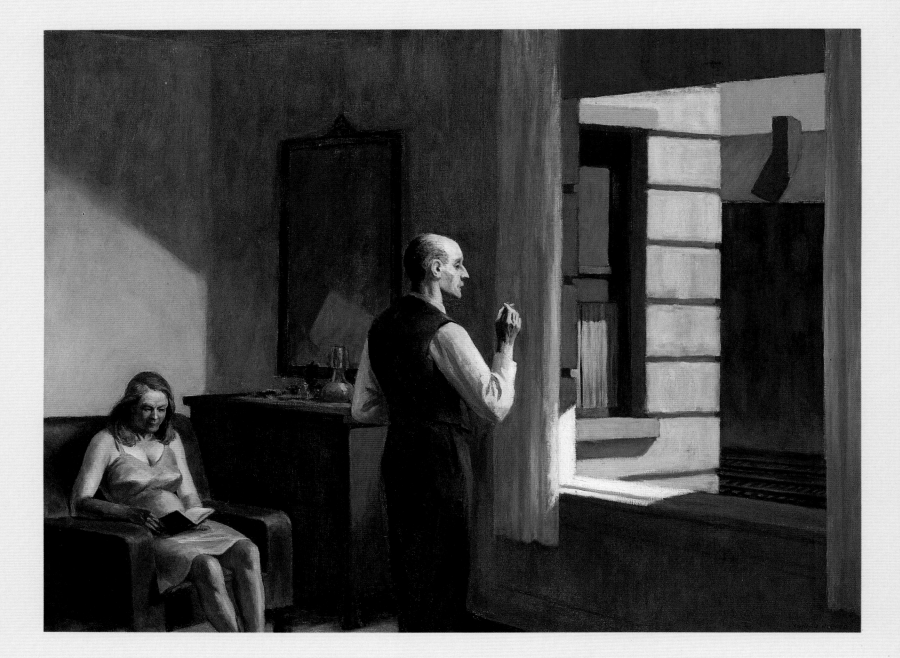

**Hotel by a Railroad**
1952, oil on canvas, 31¼×40⅛ in.
*Gift of the Joseph H. Hirshhorn*
*Foundation, 1966,*
*Hirshhorn Museum and Sculpture*
*Garden, Smithsonian Institution,*
*Washington, DC*
(66.2507)

# CITY LIFE

Some of Hopper's most haunting cityscapes show two very different kinds of moments: the moment when some unknown thing is about to happen, as in *Room in New York* and the moment that seems frozen, as in *Nighthawks*. In both paintings he tries to capture the sense of space both *inside* and *outside* a window. In both the viewer is clearly looking in through the window, and in *Room in New York* (and in *Night Windows*), there is an added implication of the presence of an unseen voyeur. To some extent Hopper was, of course, the voyeur himself, as is clear from what he said of *Room in New York*: "The idea had been in my mind a long time before I painted it. It was suggested by glimpses of lighted interiors seen as I walked along city streets at night, probably near the district where I live (Washington Square) although it's no particular street or house, but is really a synthesis of many impressions."

Hopper's reputation as the painter of loneliness, boredom and estrangement stems largely from his scenes of city life. His people really do seem to exist in what poet Robert Lowell called humanity's "wilderness of lost connections." Though Hopper himself always maintained that critics overdid "this loneliness thing," it was viewers who found, and continue to find the most characteristic aspect of his "voice", from such early cityscapes as *New York Corner* to works of his maturity such as the famous *New York Movie*.

It is no less true for being a cliche to say that any great work of art, while possessing an integrity of its own, may be variously interpreted and reinterpreted by each new viewer. Hopper's colleague Charles Burchfield clearly had this in mind when he said of Hopper that "he achieves such a complete verity that you can read into his interpretations of houses and conceptions of New York life any human implications you wish." One

might say of *Room in New York* that the man and woman are presented in stereotypical gender roles: the man, representing the world of the intellect, is reading, while the women, representing the gentler world of the arts and emotions, is about to play the piano. But is each contentedly in a private world – or, as most critics have thought, are the two estranged, with the woman about to strike a piano key in an attempt to break the heavy silence between them and communicate?

*Nighthawks*, perhaps Hopper's best known painting, has had more than its share of interpretations. Although *Nighthawks* is usually cited as the quintessential Hopper presentation of isolation, some have suggested that the couple should be seen as an expression of warmth and intimacy, in contrast to the solitary figure seated across from them. Others see *Nighthawks* as social comentary, unfavorably contrasting the harsh modernity of the diner with the older, more secure world represented by the shop with the old-fashioned cash register in its window. Still others have suggested that *Nighthawks* was inspired by Hemingway's short story *The Killers* (which Hopper liked enough to write the author a fan letter). In this interpretation the figures in the diner become sinister, not lonely, and the old fashioned cash register may be, as critic Gail Levin put it, "the focus of their evil intentions."

Hopper himself was characteristically laconic about *Nighthawks*. When critic Katharine Kuh asked if he didn't see the scene as "lonely and empty" Hopper replied, "I don't see it as particularly lonely . . . (but) unconsciously, probably I was painting the loneliness of a large city" Doubtless a large part of the appeal of Hopper's scenes of city life is that their deepest meanings speak from the unconscious of the artist to that of the viewer.

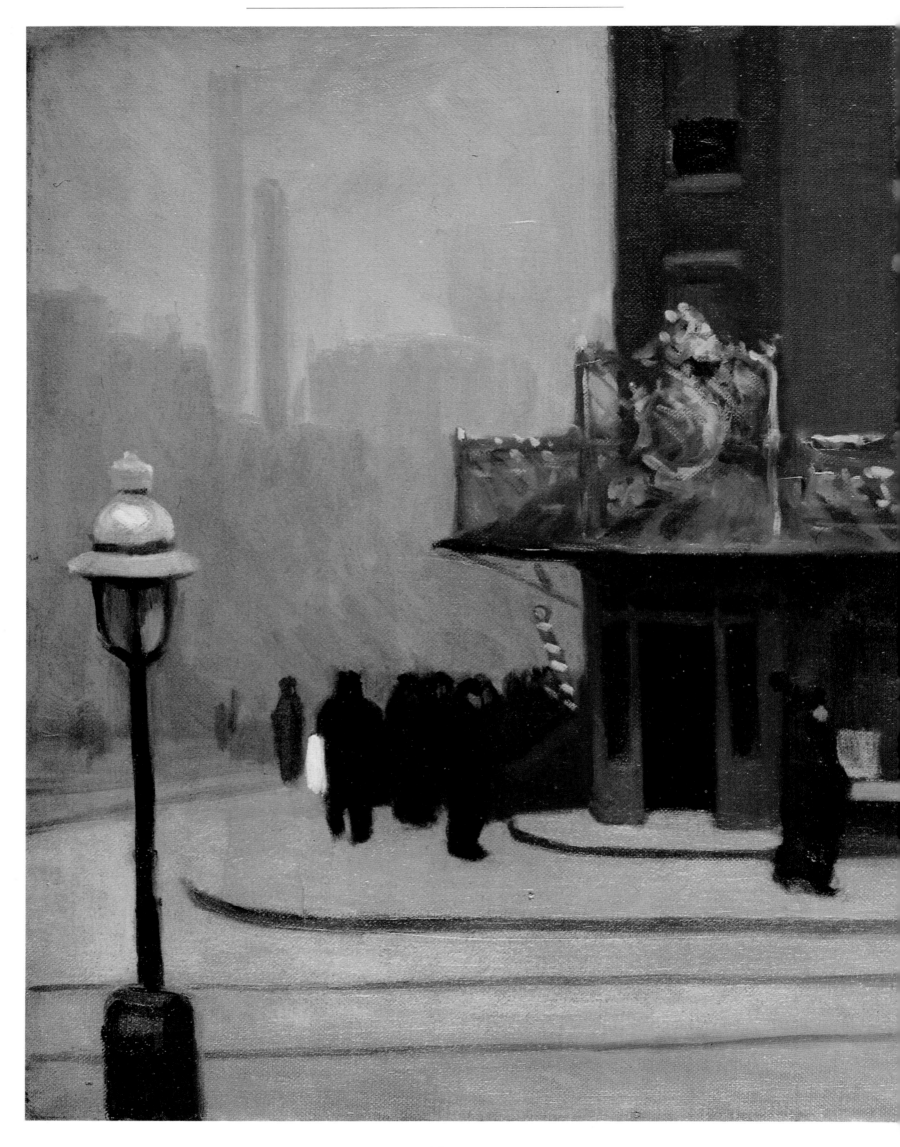

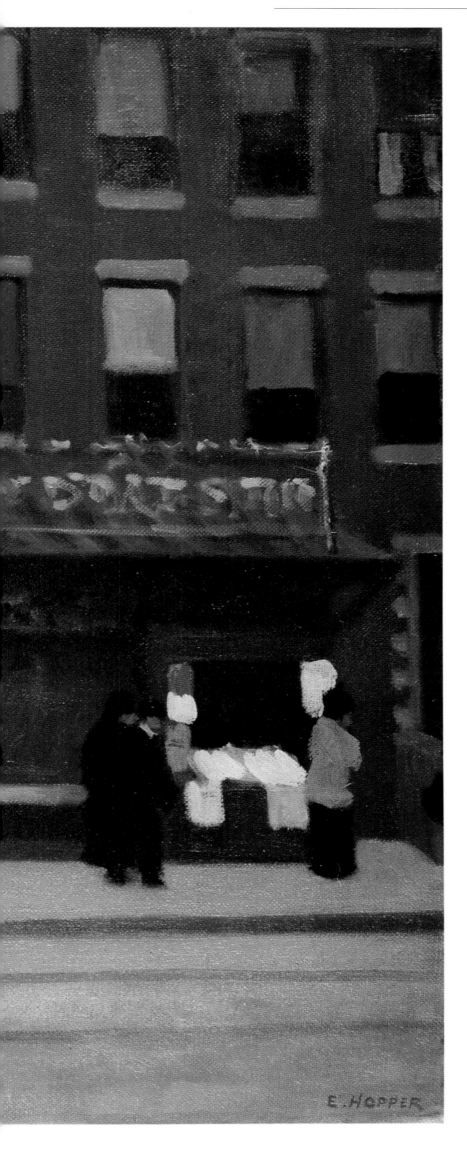

**Corner Saloon**
1913, oil on canvas, 24×29 in.
*Abby Aldrich Rockefeller Fund,*
*Collection, The Museum of Modern Art,*
*New York, NY*

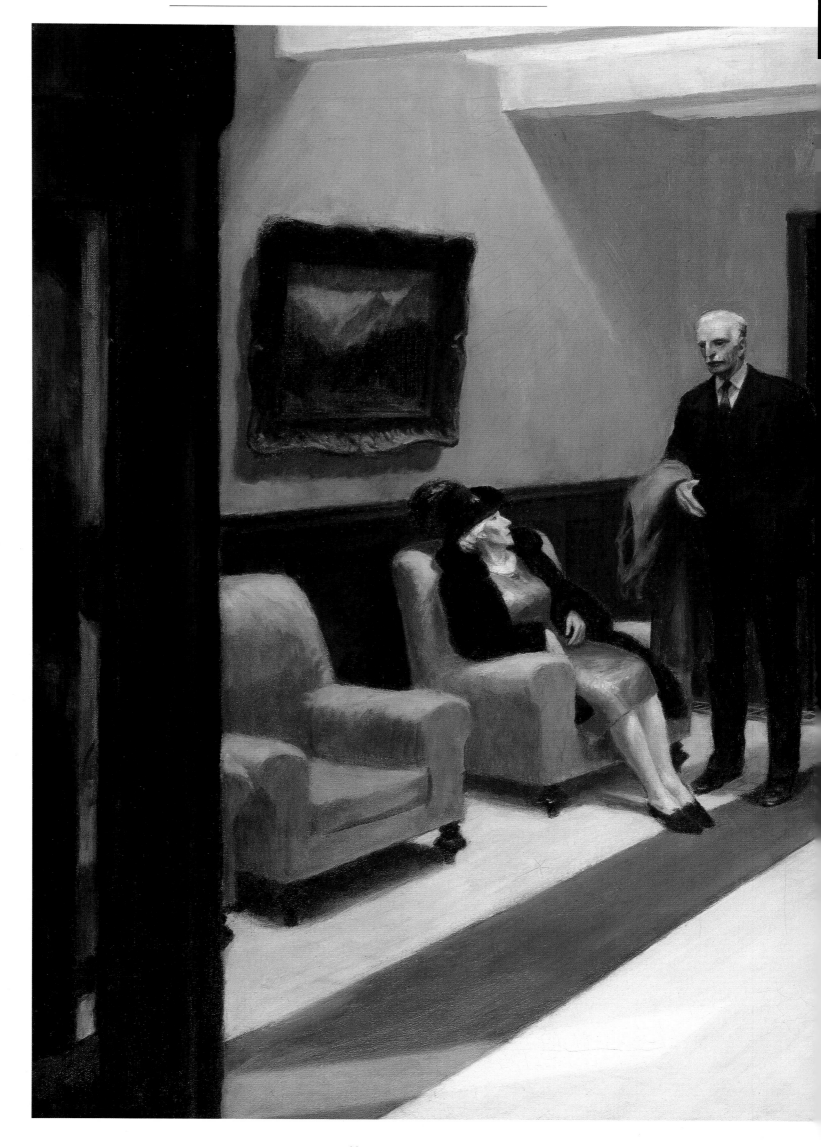

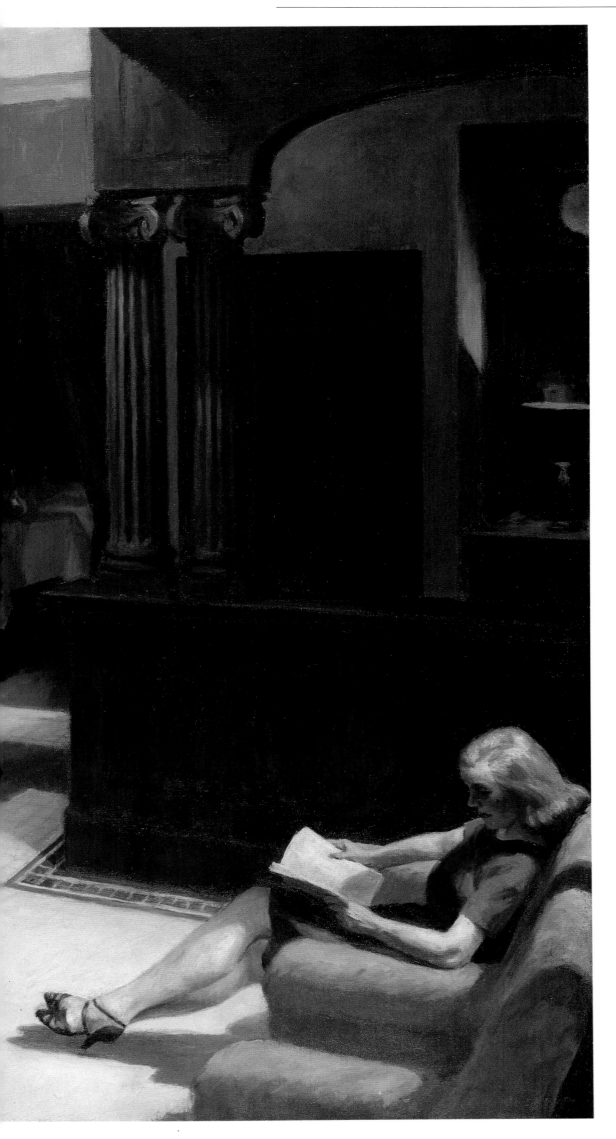

**Hotel Lobby**
1943, oil on canvas, 32¼×40¾ in.
*William Ray Adams Memorial Collection,*
© *1989 Indianapolis Museum of Art, IN*
(47.4)

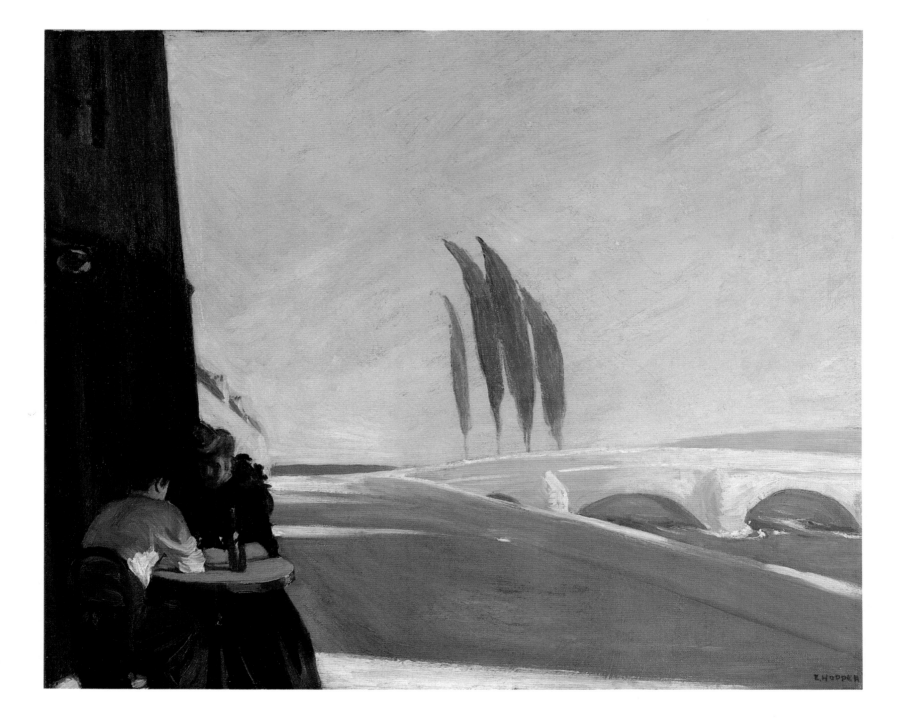

**Le Bistro** or **The Wine Shop**
1909, oil on canvas, 23⅜×28½ in.
*Bequest of Josephine N. Hopper,*
*Collection of Whitney Museum of American*
*Art, New York, NY*
(70.1165)

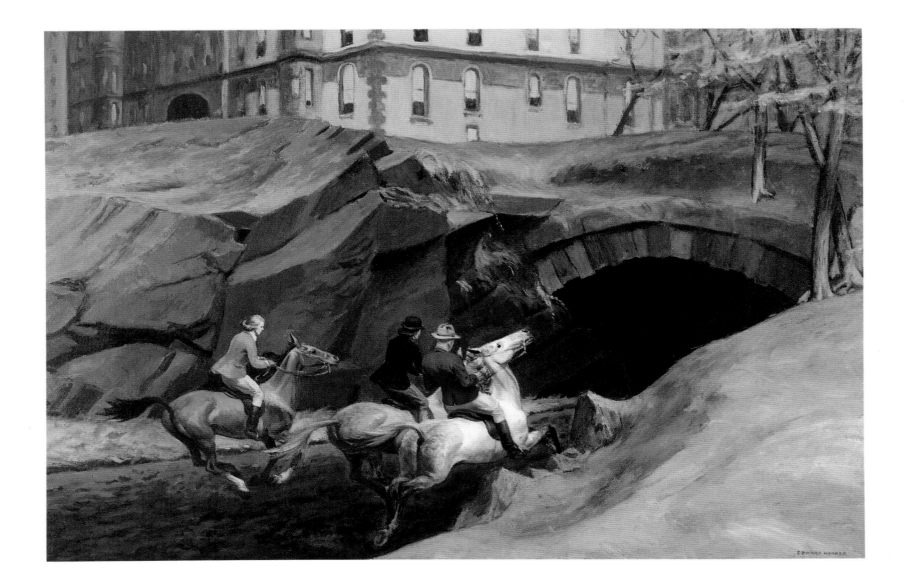

**Bridle Path**
1939, oil on canvas, 28⅜×42⅛ in.
*Anonymous Gift,*
*San Francisco Museum of Modern Art, CA*
(76.174)

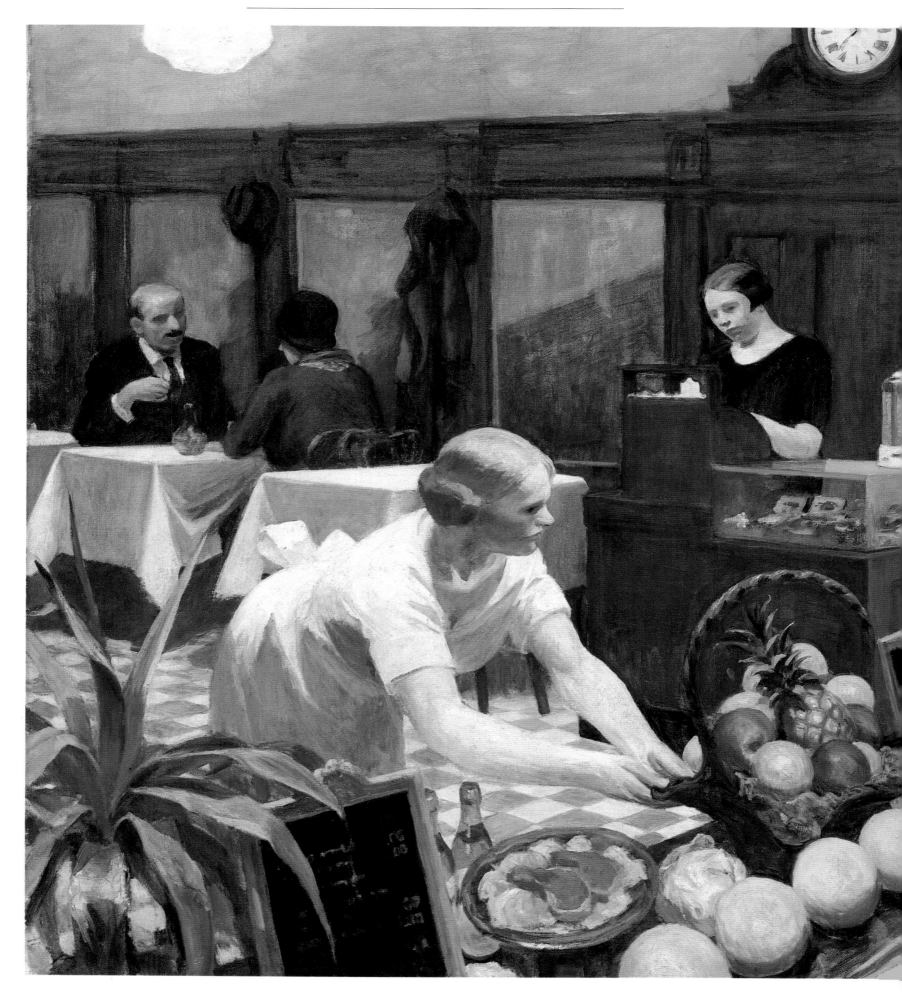

**Tables for Ladies**
1930, oil on canvas, 48¼×60¼ in.
*George A. Hearn Fund, 1931,*
*The Metropolitan Museum of Art, New*
*York, NY*
(31.62)

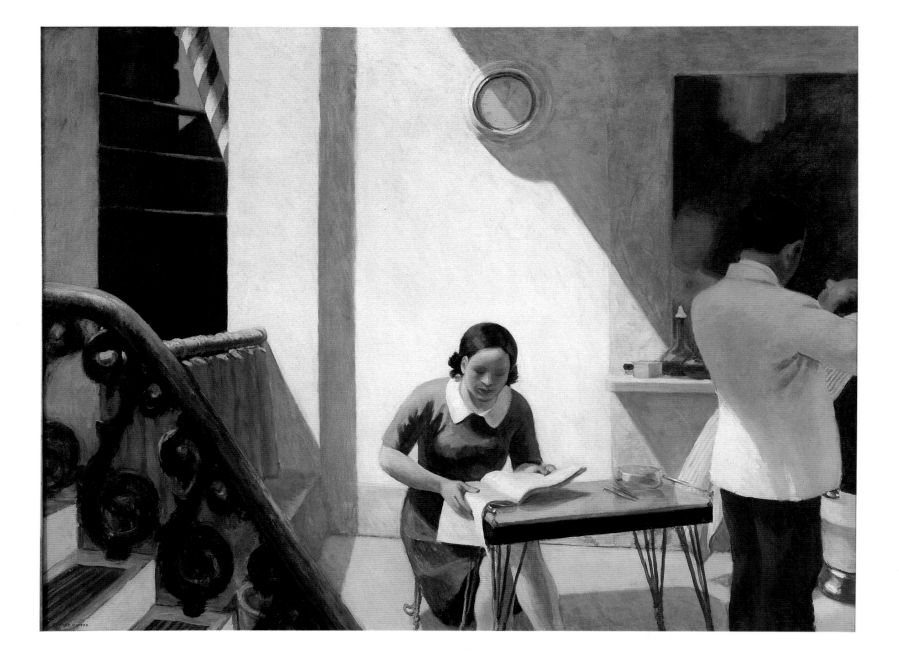

**The Barber Shop**
1931, oil on canvas, 60×78 in.
*Gift of Roy R. Neuberger,*
*Collection of Neuberger Museum, State*
*University of New York at Purchase, NY*

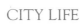

**Two on the Aisle**
1927, oil on canvas, 40⅛×48¼ in.
*Gift of Edward Drummond Libbey,*
*The Toledo Museum of Art, OH*

**First Row Orchestra**
1951, oil on canvas, 31⅛×40⅛ in.
*Gift of Joseph H. Hirshhorn Foundation,*
*1966,*
*Hirshhorn Museum and Sculpture Garden,*
*Smithsonian Institution, Washington, DC*
*(66.2506)*

Pages 78-79:
**New York Movie**
1939, oil on canvas, 32¼×40⅛ in.
*Given anonymously,*
*Collection, The Museum of Modern Art,*
*New York, NY*

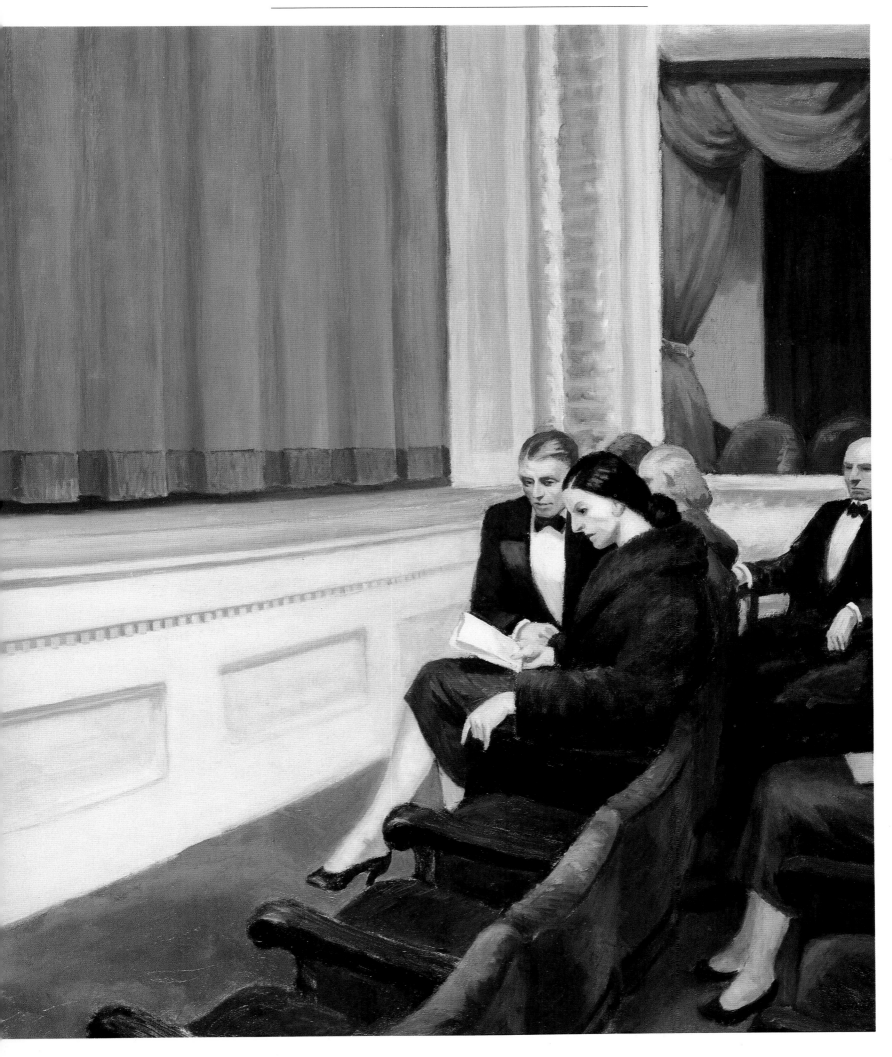

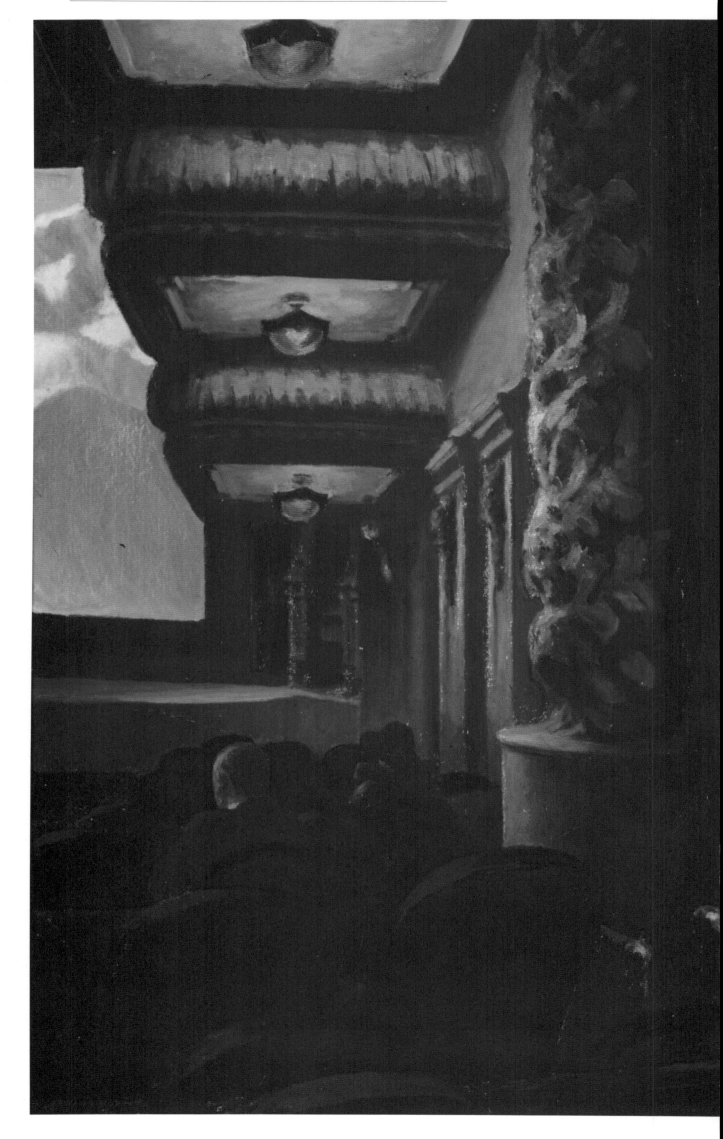

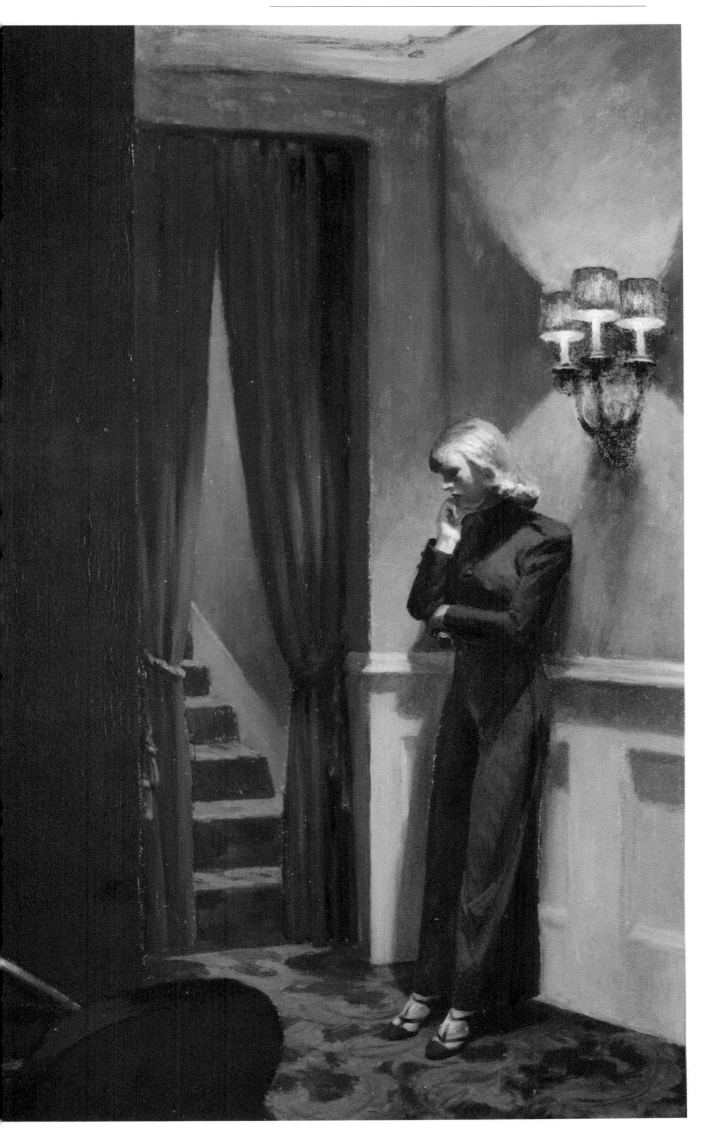

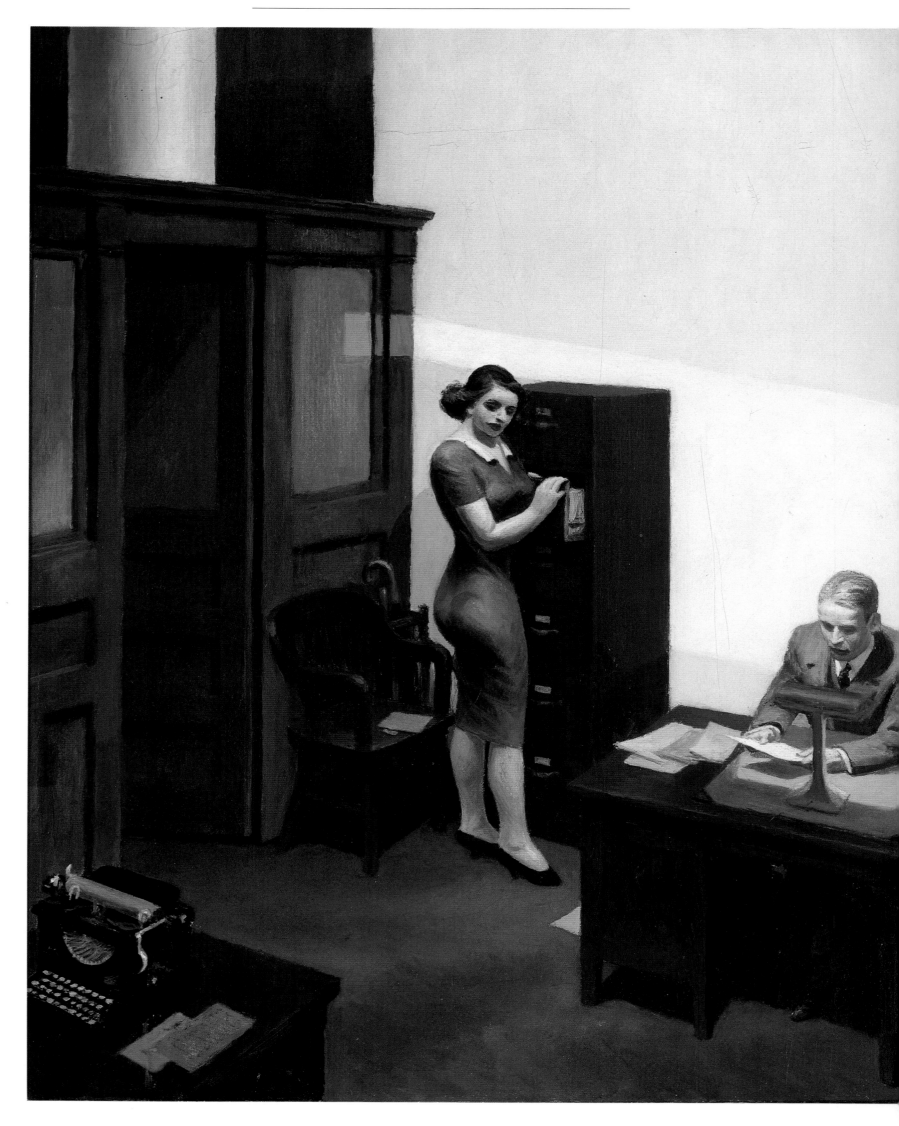

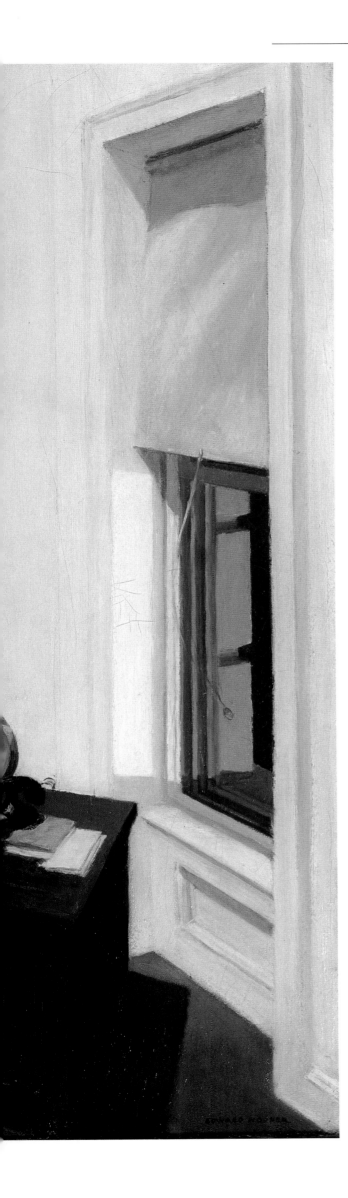

**Office at Night**
1940, oil on canvas, 22⅛×25 in.
*Gift of the T.B. Walker Foundation,*
*Gilbert M. Walker Fund, 1948,*
*Walker Art Center, Minneapolis, MN*
(48.21)

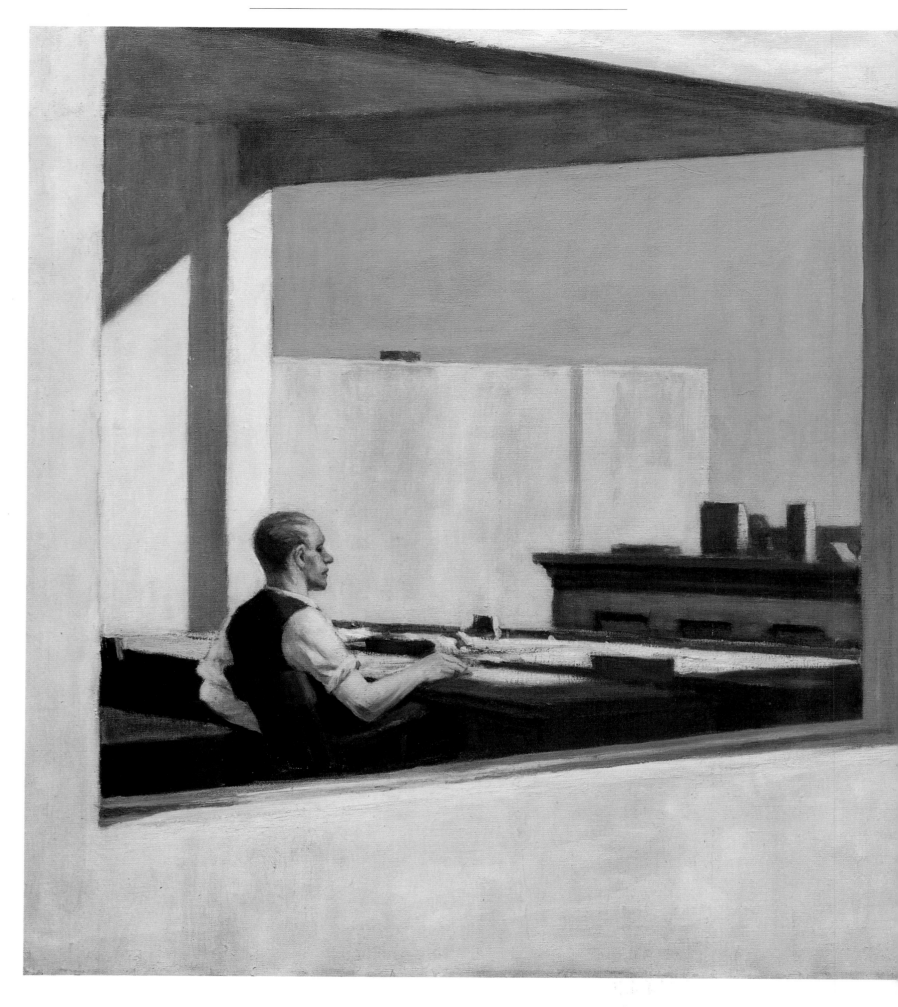

**Office in a Small City**
1953, oil on canvas, 28×40 in.
*George A. Hearn Fund, 1953,*
*The Metropolitan Museum of Art,*
*New York, NY*
(53.183)

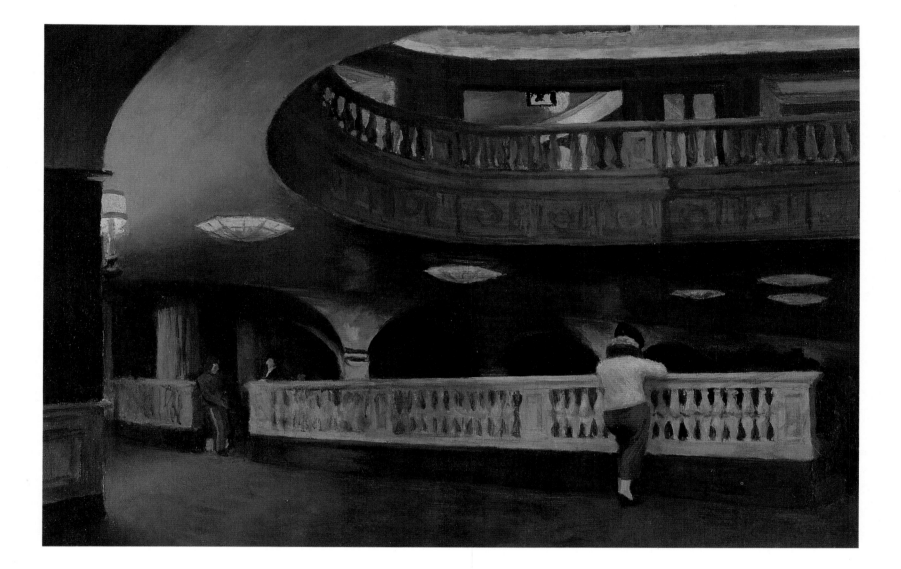

**Sheridan Theatre**
1937, oil on canvas, 17⅛×25¼ in.
*Purchase 1940, Felix Fuld Fund,*
*Collection of The Newark Museum, NJ*
(40.118)

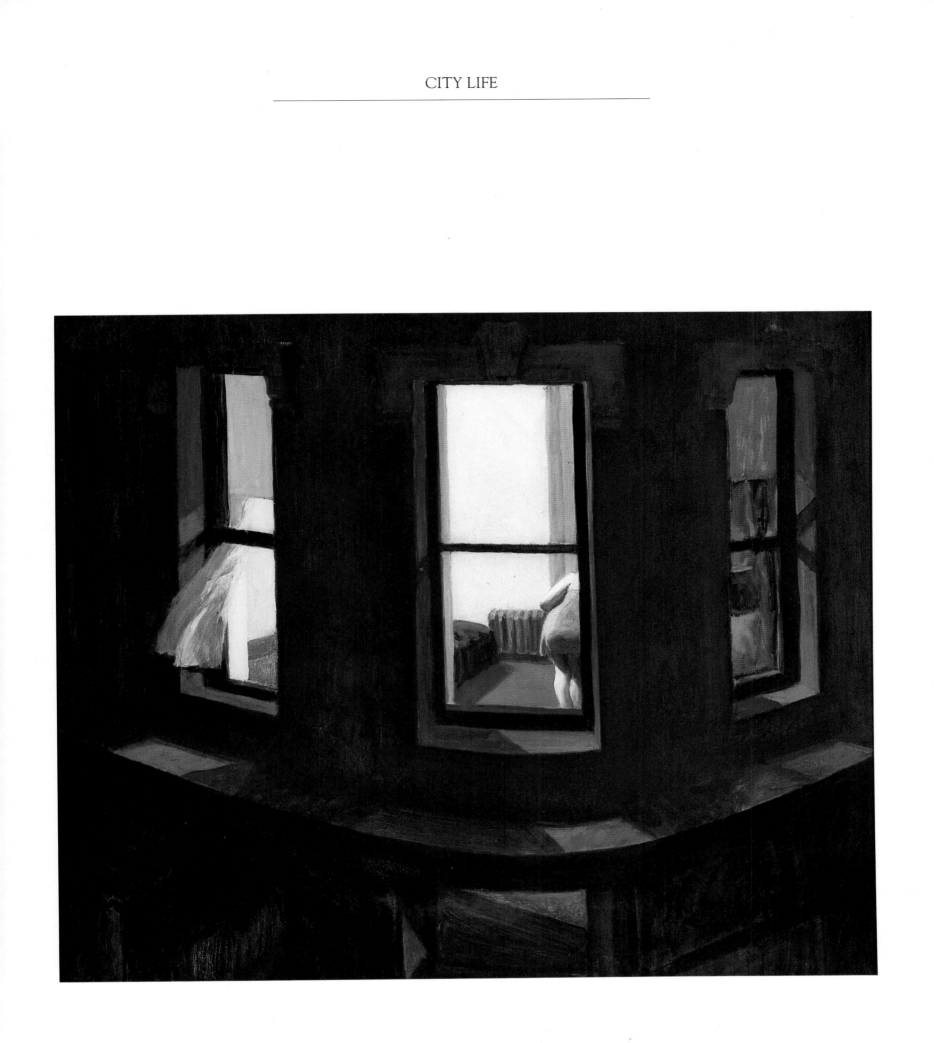

**Night Windows**
1928, oil on canvas, 29×34 in.
*Gift of John Hay Whitney,*
*Collection, The Museum of Modern Art,*
*New York, NY*

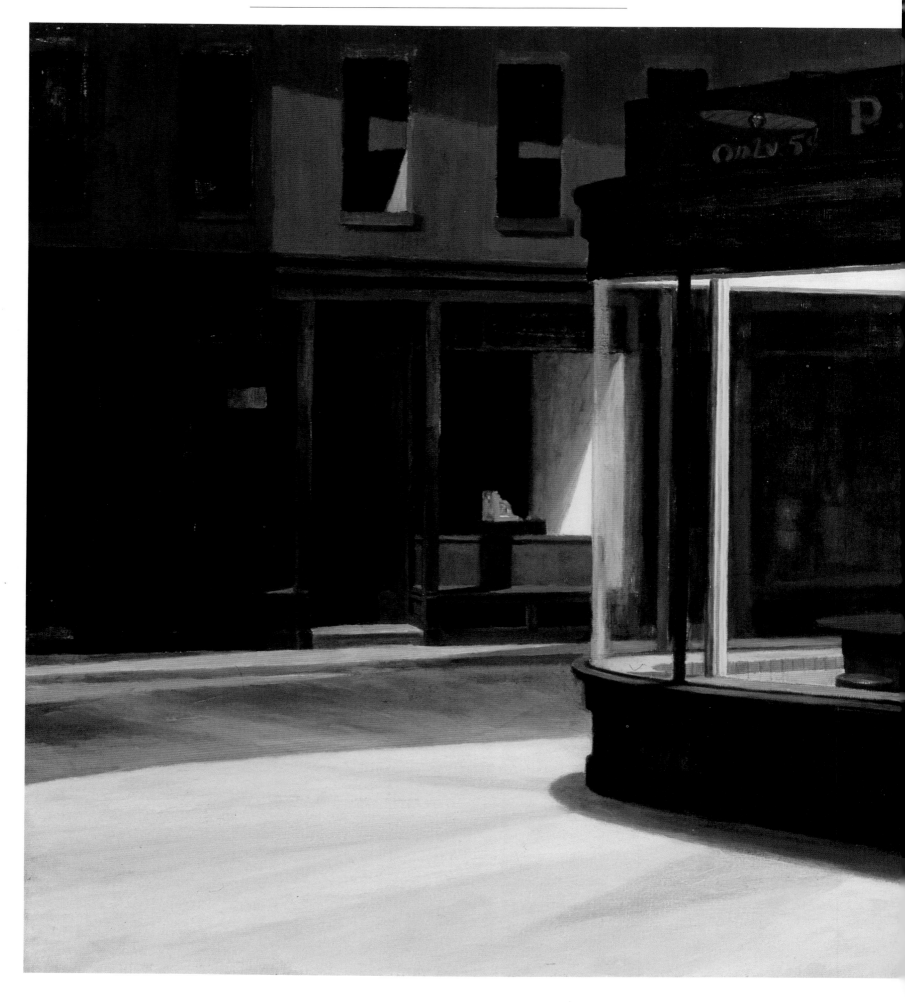

**Nighthawks**
1942, oil on canvas, 30×56¾ in.
*Friends of American Art Collection,*
ⓒ *1989 The Art Institute of Chicago, IL*
(1942.51)

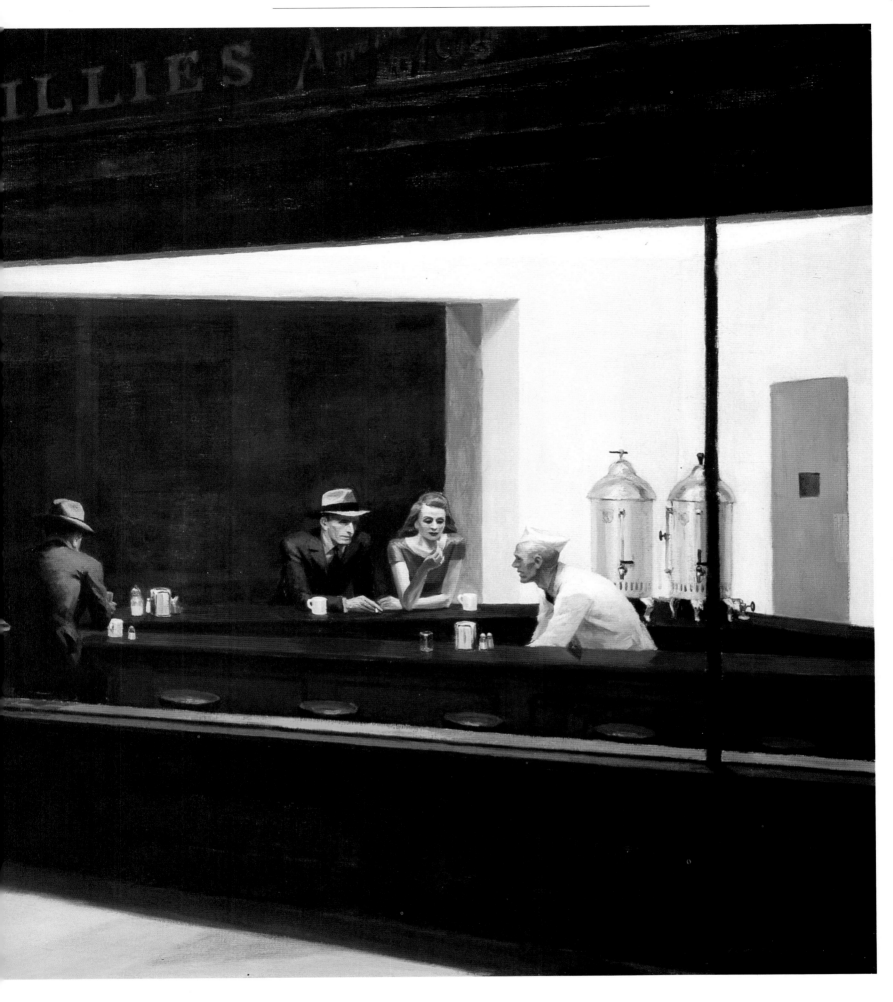

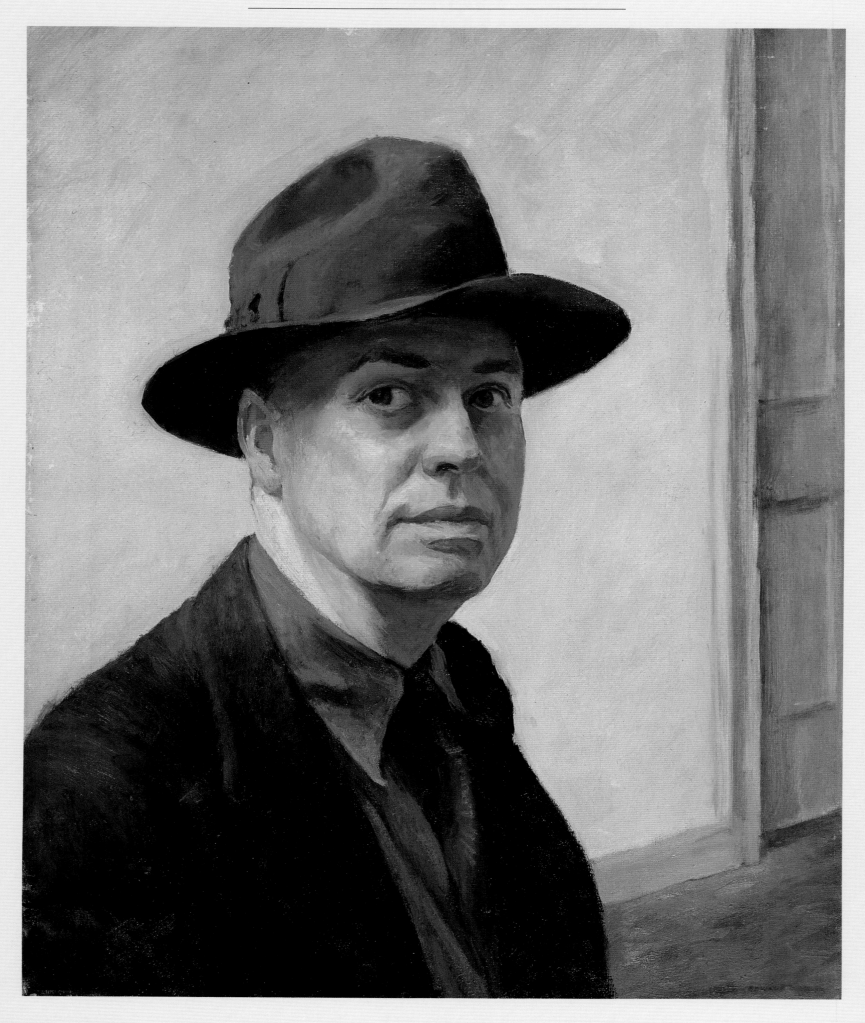

**Self-Portrait**
1925-30, oil on canvas, 25⅟₁₆ × 20⅜ in.
*Bequest of Josephine N. Hopper,*
*Collection of Whitney Museum of American*
*Art, New York, NY*
(70.1165)

# THE HUMAN IMAGE

The poet Wallace Stevens once said that, "Life is an affair of people, not of places. But for me life is an affair of places, and that is the trouble." Stevens' self-analysis applies equally to Hopper, whose people so often appear curiously extraneous to the world they inhabit. Perhaps only in his handful of portraits, where the focus is unreservedly on a specific individual, does Hopper communicate a sense of immediacy and reality to the human image. The subjects of *The Artist's Mother, Self Portrait* and *Jo in Wyoming* are clearly distinct individuals, and we are not really surprised to learn that the provocative woman in *Reclining Nude* is Jo, painted shortly after she and Hopper married.

One of Hopper's most mysterious paintings, one of his personal favorites and one that has never received much critical acclaim is his early *Soir Bleu.* The painting not only implies the importance of Hopper's stay in Paris, it so strongly suggests the influence of the French symbolists that we can only wonder whether Hopper was more attuned to trends in French painting than he later recalled.

Jo Hopper once said that her husband "could never paint a pretty girl," a rather courageous remark coming from the woman who modeled for every female figure Hopper did after 1924. Be that as it may, Hopper painted far more women than men over the years, and Hopper's women (like "Hopper Houses") have a strong family resemblance: full-busted, almost statuesque, preoccupied and unreachable. These women are most often shown alone, as in *Morning Sun* and *Western Motel,* although in both these paintings, as so often with Hopper, the viewer has a sense of sharing the scene with an unseen figure. In *Morning Sun* this is the understood voyeur, while in *Western Motel* it is the implied figure of the woman's companion.

In *Second Story Sunlight* a young woman (whom Hopper and Jo nicknamed "Toots" in their daybook) sits on the edge of a balcony, straining forward, apparently, toward the world beyond. In the background, seated in a chair, is an older woman, withdrawn, it seems, from life. Everything about the young woman – her pose, her glance, her costume – suggests that she (like the young woman in *Summertime*) is eager to embrace life, while the older woman seems to be reconciled to watching life go by. Characteristically, when Hopper was asked about *Second Story Sunlight* he brushed aside the picture's psychological implications: "This picture is an attempt to paint sunlight as white with no or almost no yellow pigment in the white. Any psychological idea will have to be supplied by the viewer."

Hopper's preoccupation with light was a constant, from his earliest sketches in Paris to his penultimate painting, *Sun in an Empty Room.* The list of Hopper titles containing the word "light" (*Sunlight in Cafeteria*) or "sun" (*Morning Sun*) or referring to a time of day (*Eleven A.M.*) could be extended almost indefinitely.

It comes as something of a shock to discover that after a lifetime of disavowing most of the meanings attributed to his work and avoiding any narrative whatsoever in his painting, Hopper's last painting was overtly didactic. The painter was in failing health when he did *Two Comedians* (1965), which he intended as his and Jo's valedictory. Hopper and his wife were the two comedians, and the painting shows the couple as bathed in a spotlight. Behind them is darkness, the ultimate darkness of death. The painting was Hopper's way of saying that "all the world's a stage" and of taking his last bow.

**Gas**
1940, oil on canvas, 26¼×40¼ in.
*Mrs. Simon Guggenheim Fund,*
*Collection, The Museum of Modern Art,*
*New York, NY*

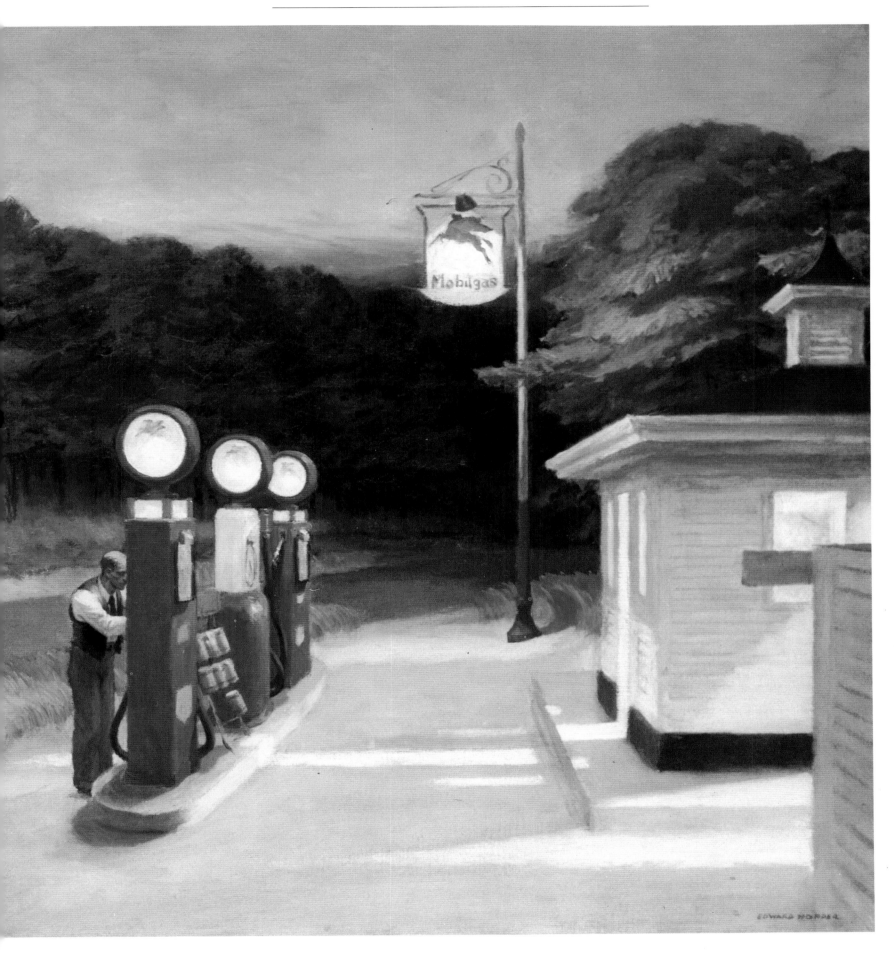

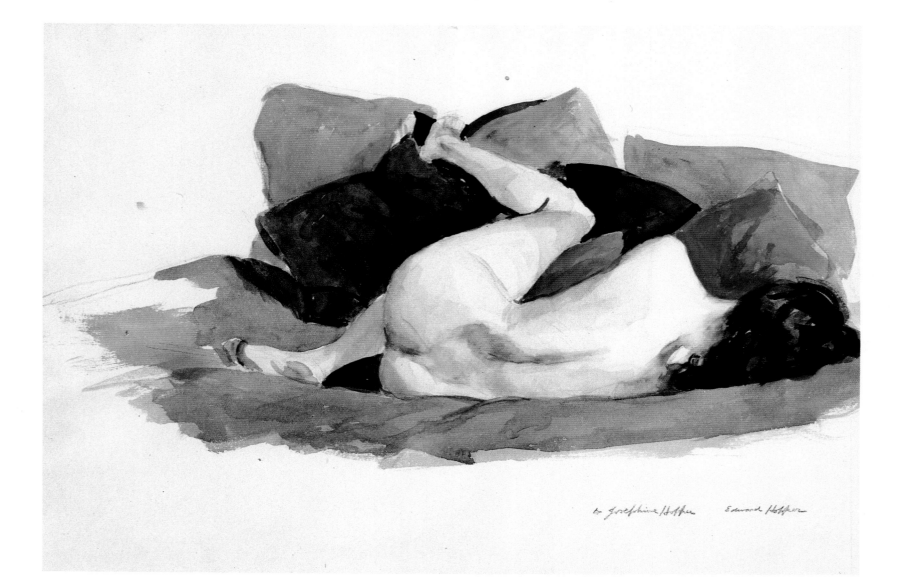

**Reclining Nude**
c. 1924-27, watercolor on paper,
13⅞×19⅞ in.
*Bequest of Josephine N. Hopper,*
*Collection of Whitney Museum of American*
*Art, New York, NY*
*(70.1089)*

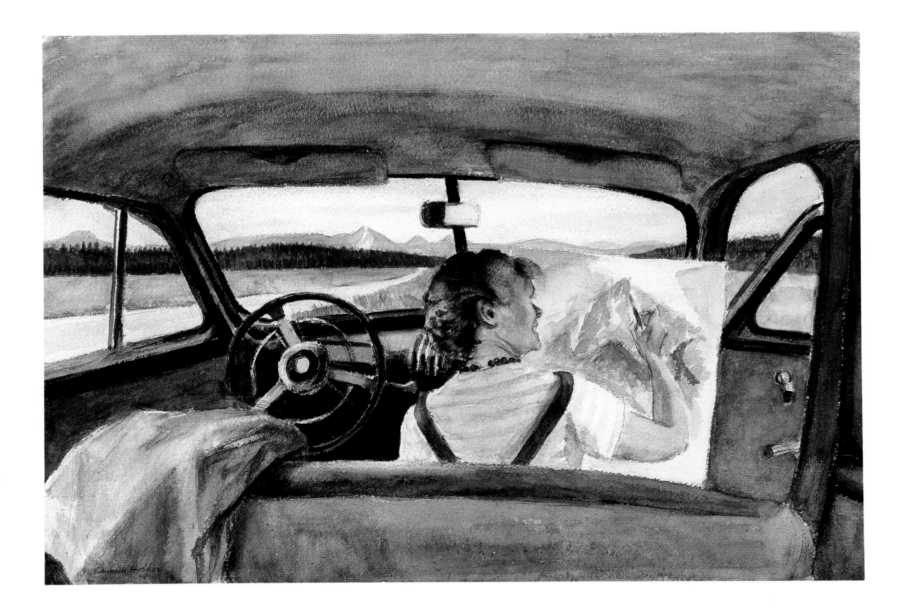

**Jo in Wyoming**
1946, watercolor on paper, 13¹⁵⁄₁₆×20 in.
*Bequest of Josephine N. Hopper,*
*Collection of Whitney Museum of American*
*Art, New York, NY*
(70.1159)

Pages 94-95:
**A Woman in the Sun**
1961, oil on canvas, 40×60 in.
*50th Anniversary Gift of Mr. and Mrs.*
*Albert Hackett in honor of Edith and Lloyd*
*Goodrich,*
*Collection of Whitney Museum of American*
*Art, New York, NY*
(84.31)

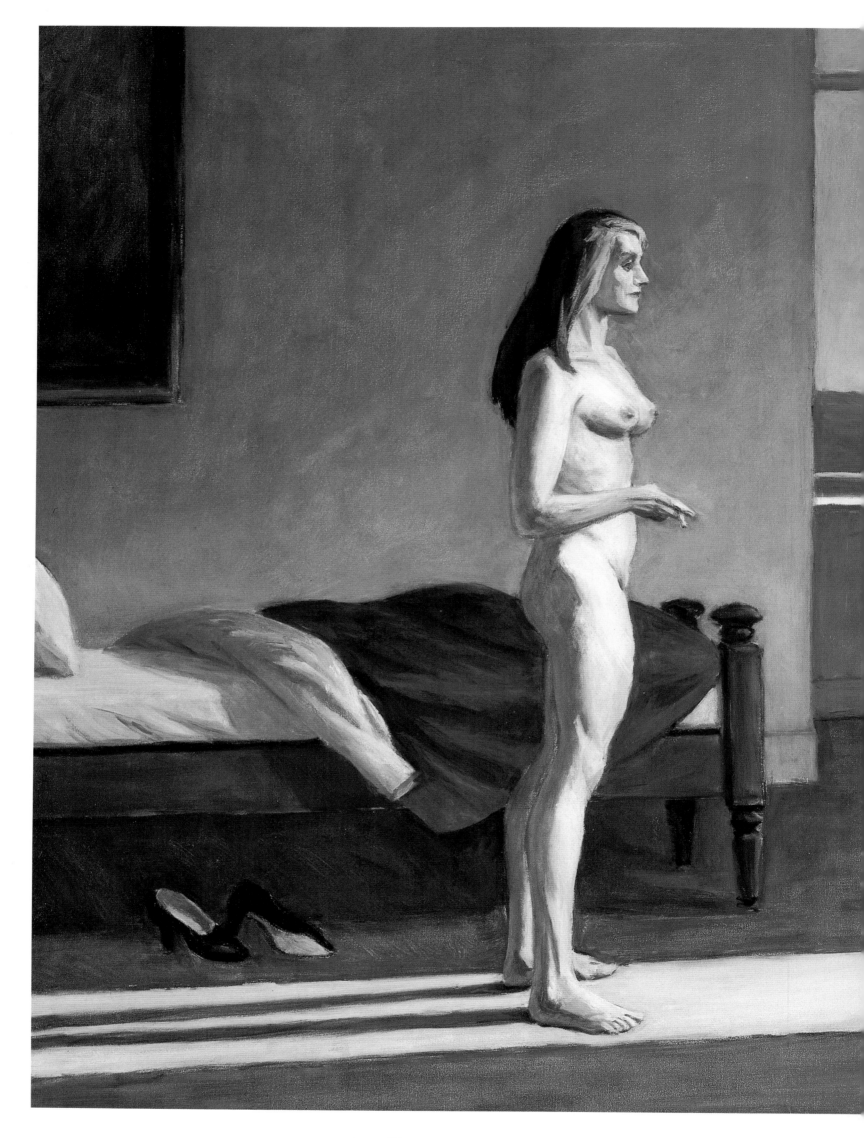

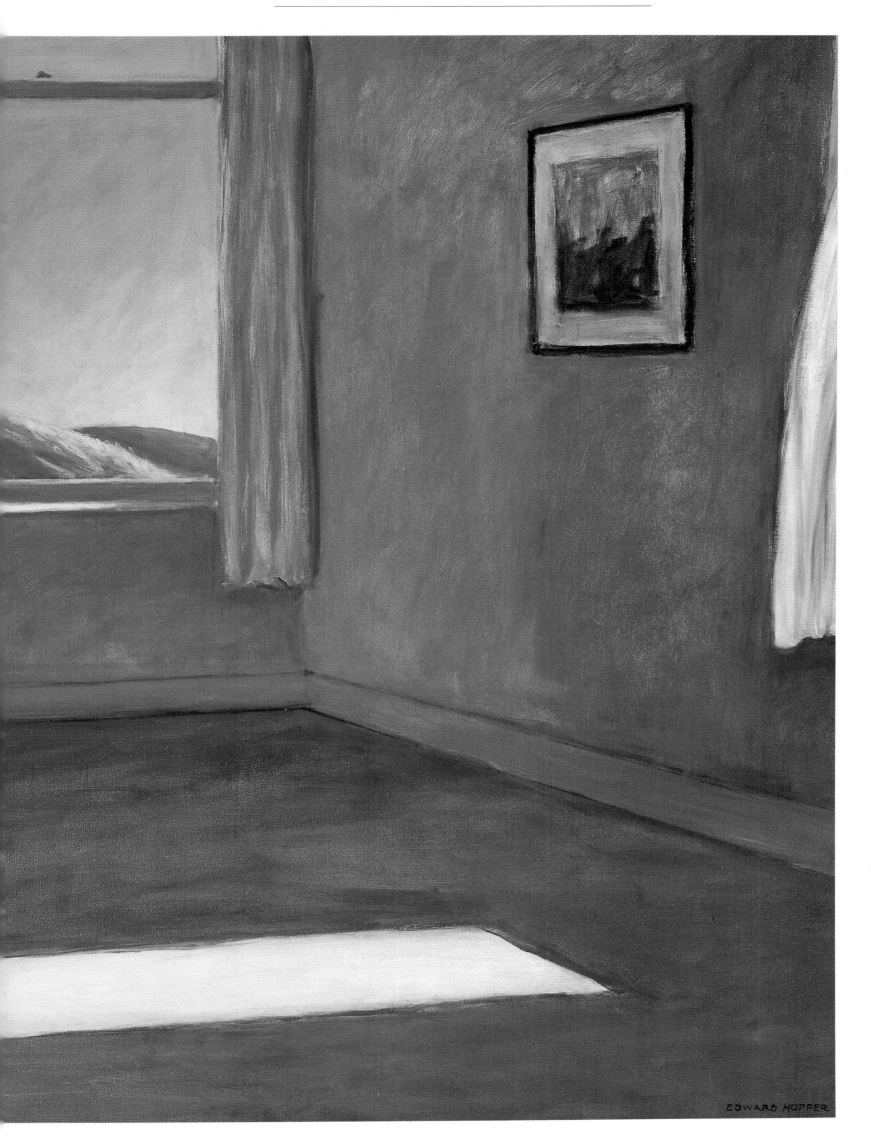

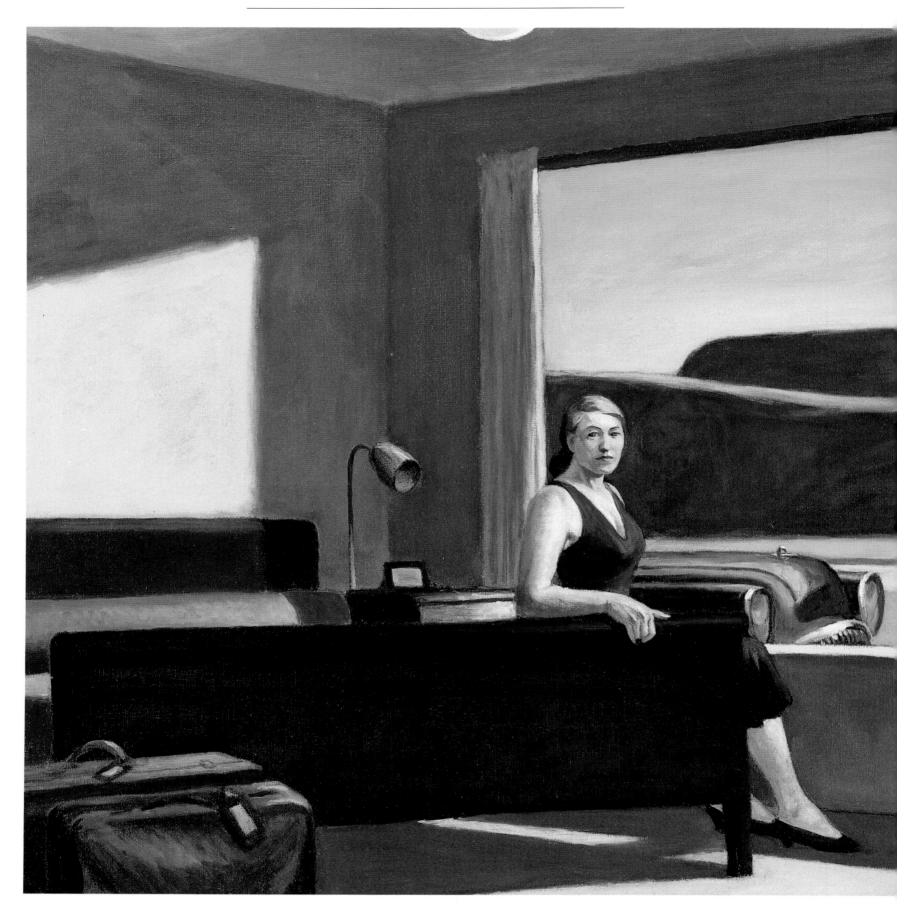

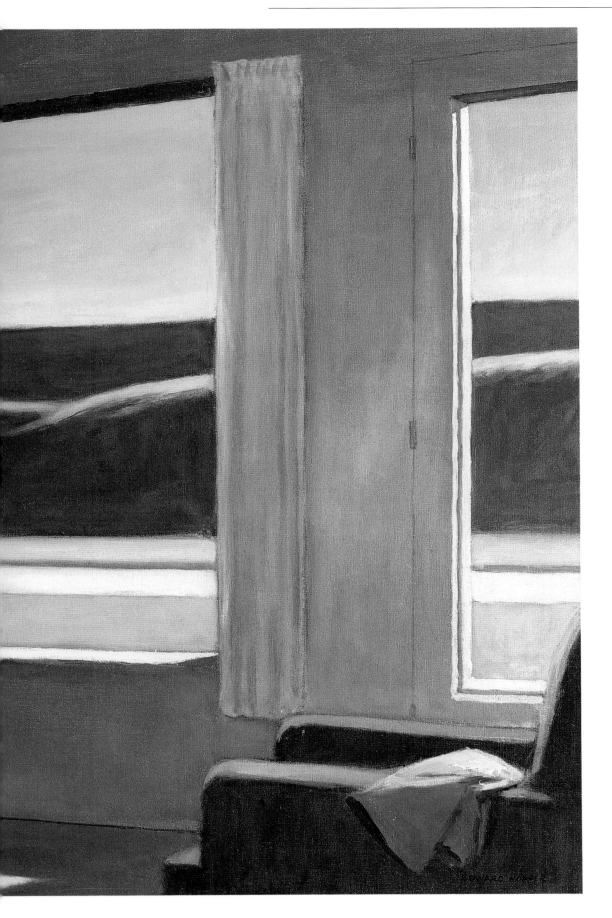

**Western Motel**
1957, oil on canvas, 30¼×50⅛ in.
*Bequest of Stephen Carlton Clark,*
*Yale University Art Gallery, New Haven,*
*CT*
(1961.18.32)

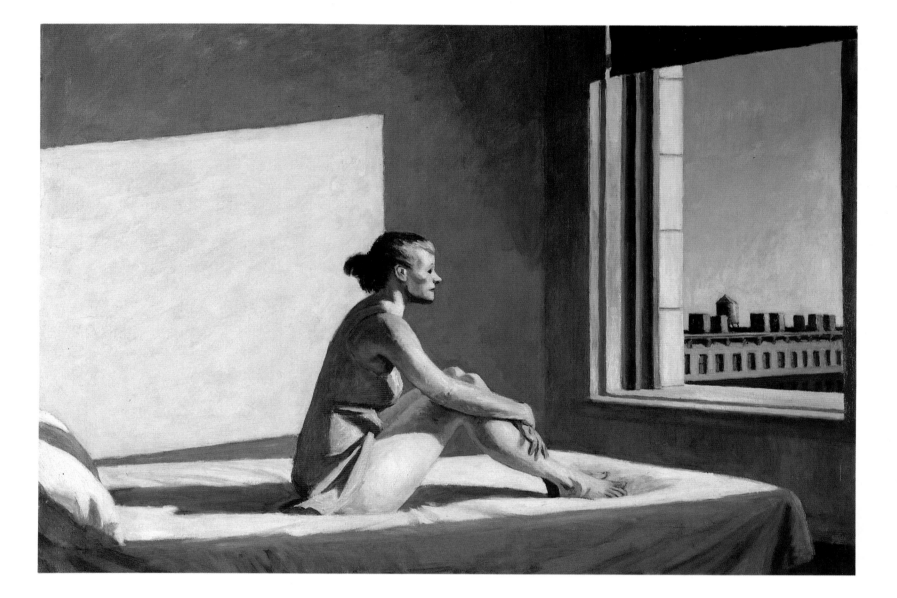

**Morning Sun**
1952, oil on canvas, 28⅛×40⅛ in.
*Museum Purchase – Howald Fund,*
*Columbus Museum of Art, OH*
(54.31)

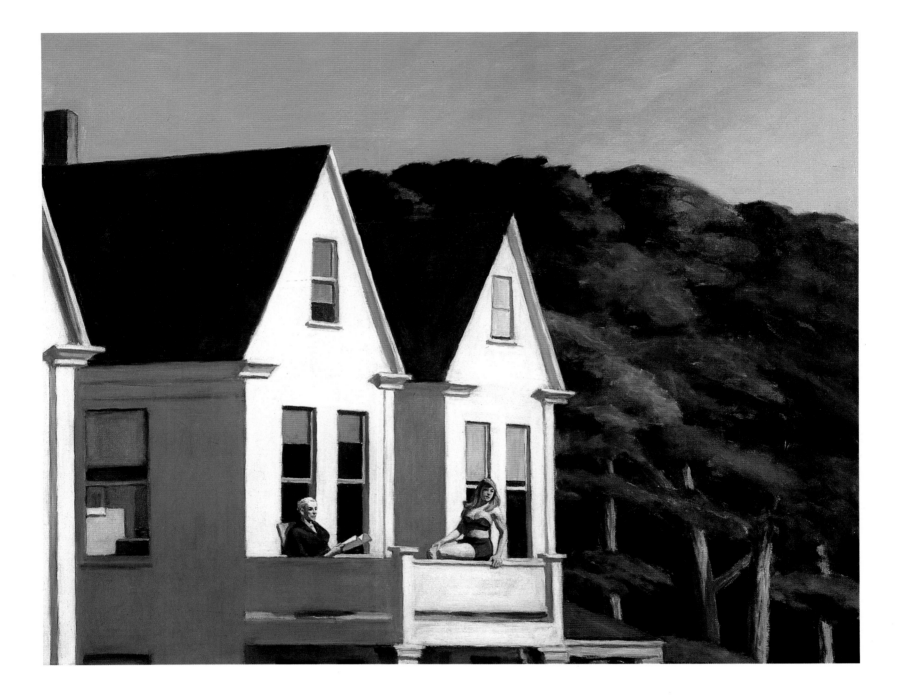

**Second Story Sunlight**
1960, oil on canvas, 40×50 in.
*Purchase, with funds from the Friends of the*
*Whitney Museum of American Art,*
*Collection of Whitney Museum of American*
*Art, New York, NY*
(60.54)

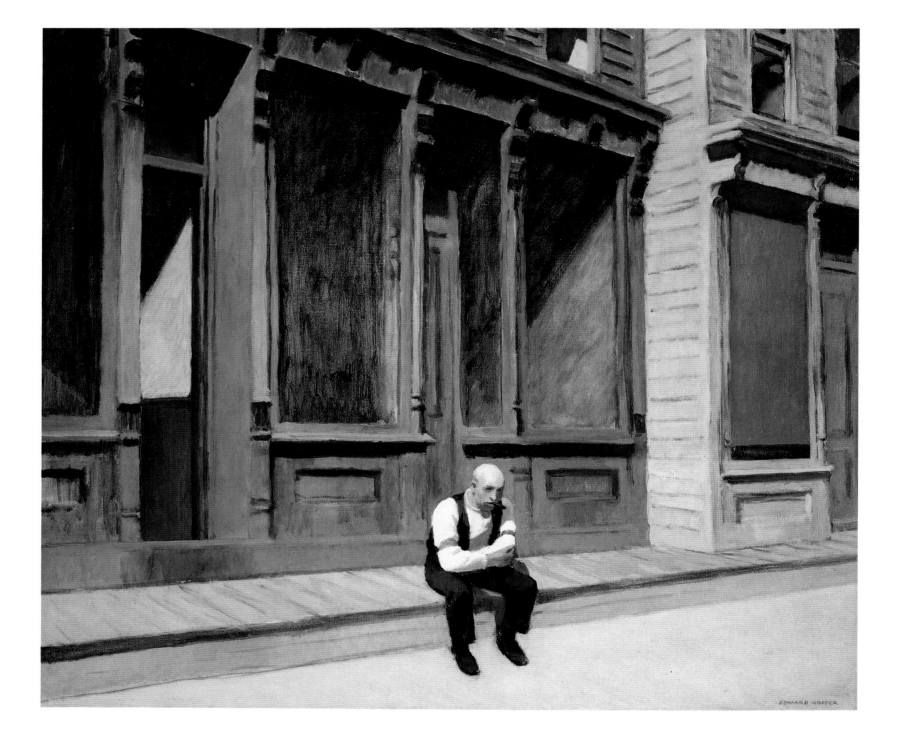

**Sunday**
1926, oil on canvas, 29×34 in.
*The Phillips Collection, Washington, DC*

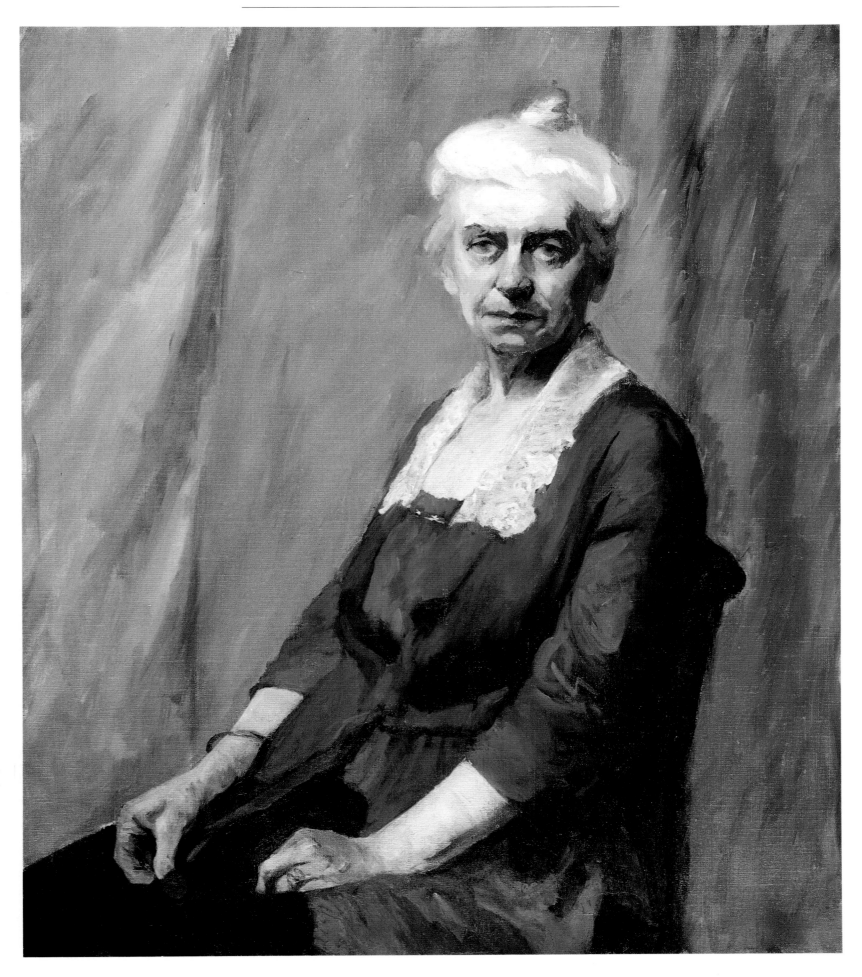

**Elizabeth Griffiths Smith Hopper,**
**The Artist's Mother**
1915-16, oil on canvas, 38×32 in.
*Bequest of Josephine N. Hopper,*
*Collection of Whitney Museum of American*
*Art, New York, NY*
(70.1191)

**Automat**
1927, oil on canvas, 28⅛×36 in.
*James D. Edmundson Fund,*
*Des Moines Art Center, IA*

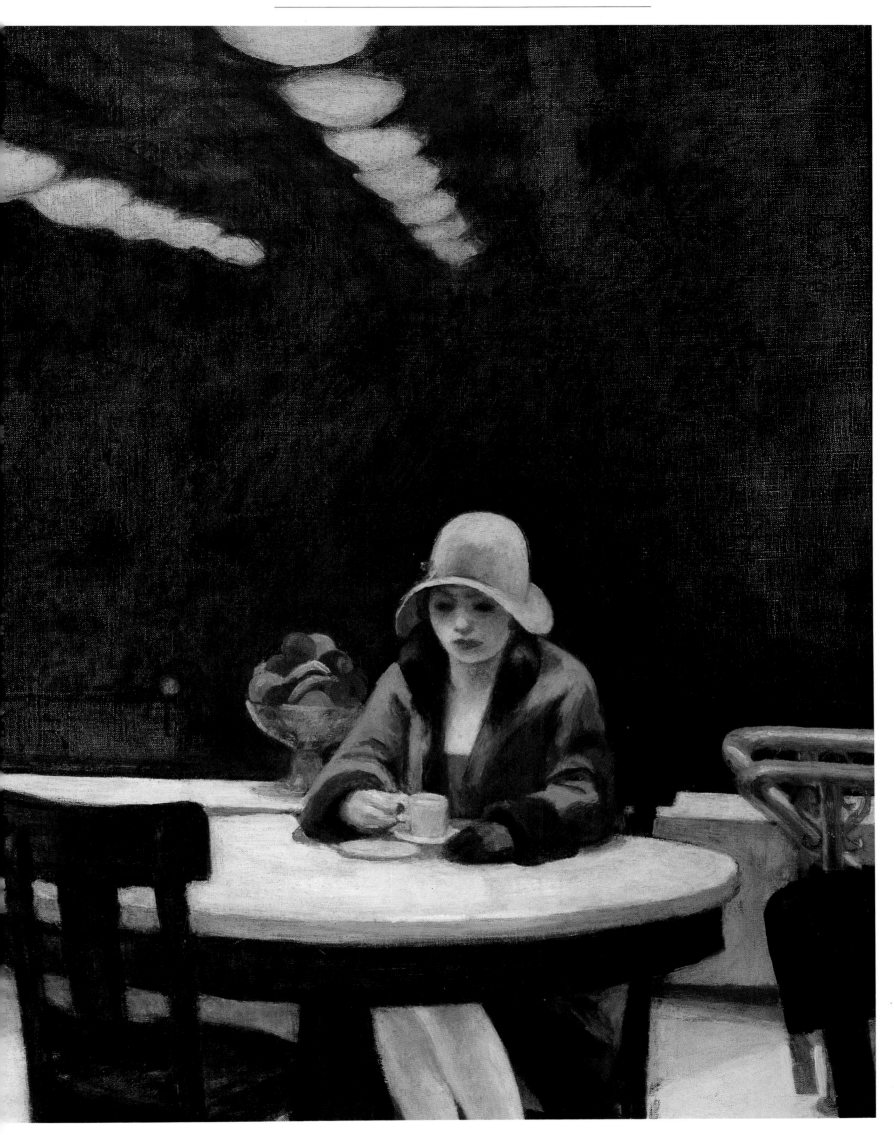

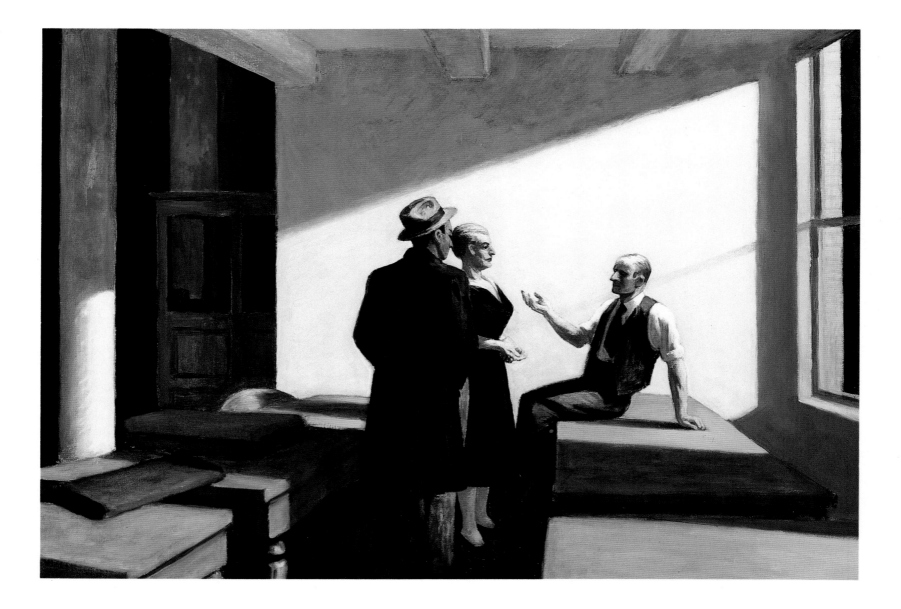

**Conference at Night**
c. 1949, oil on canvas, 27¾×40 in.
*The Roland P. Murdock Collection,*
*Courtesy Wichita Art Museum, KS*

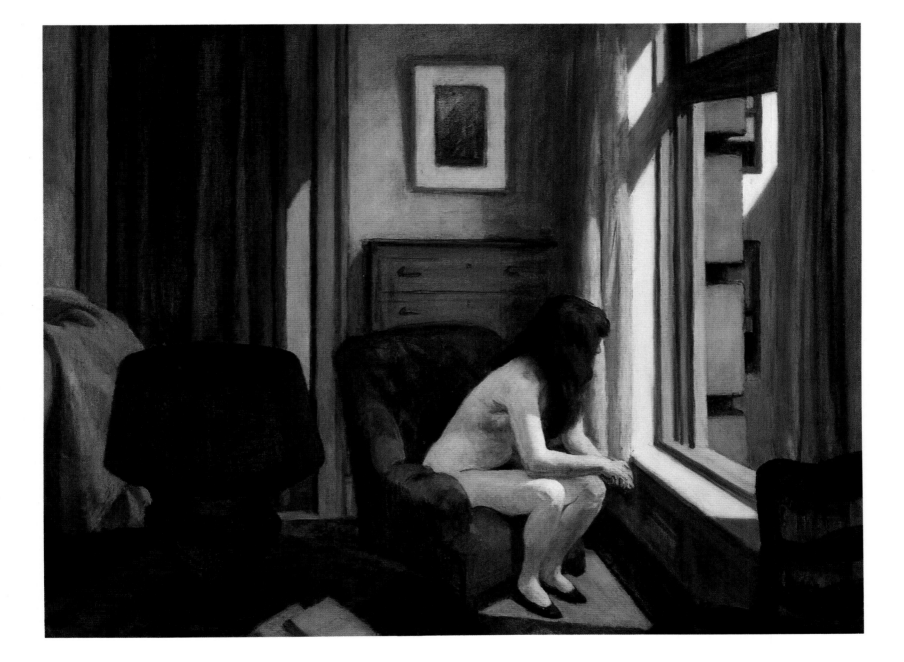

**Eleven A.M.**
1926, oil on canvas, 28⅛×36⅛ in.
*Gift of the Joseph H. Hirshhorn Foundation,*
*1966,*
*Hirshhorn Museum and Sculpture Garden,*
*Smithsonian Institution, Washington, DC*
(66.2504)

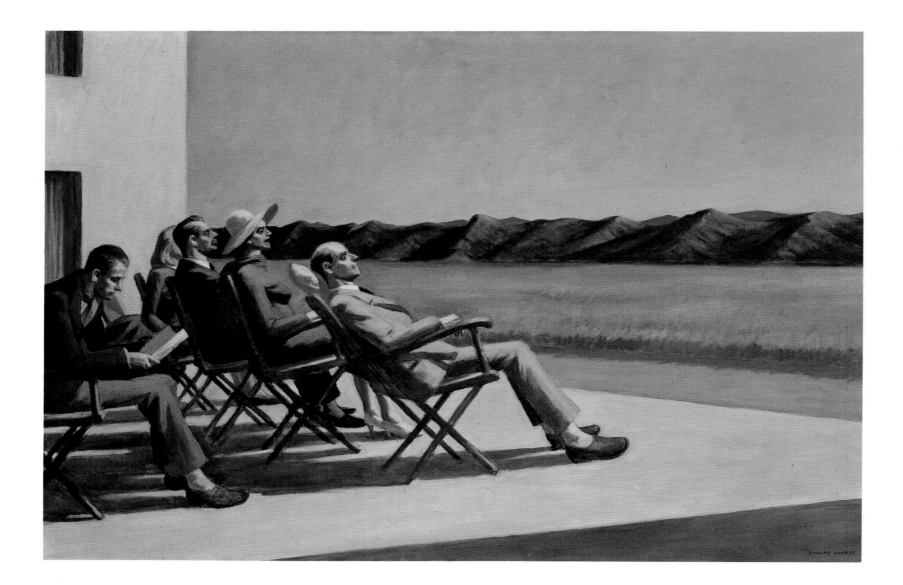

**People in the Sun**
1960, oil on canvas, 40⅜×60⅜ in.
*Gift of S.C. Johnson & Son, Inc.,*
*National Museum of American Art,*
*Smithsonian Institution, Washington, DC*
(1969.47.61)

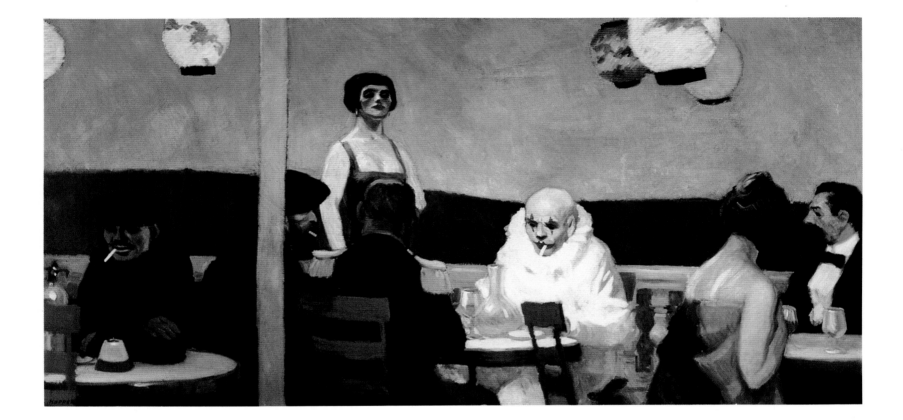

**Soir Bleu**
1914, oil on canvas, 36×72 in.
*Josephine N. Hopper Bequest,*
*Collection of Whitney Museum of American*
*Art, New York, NY*
(70.1208)

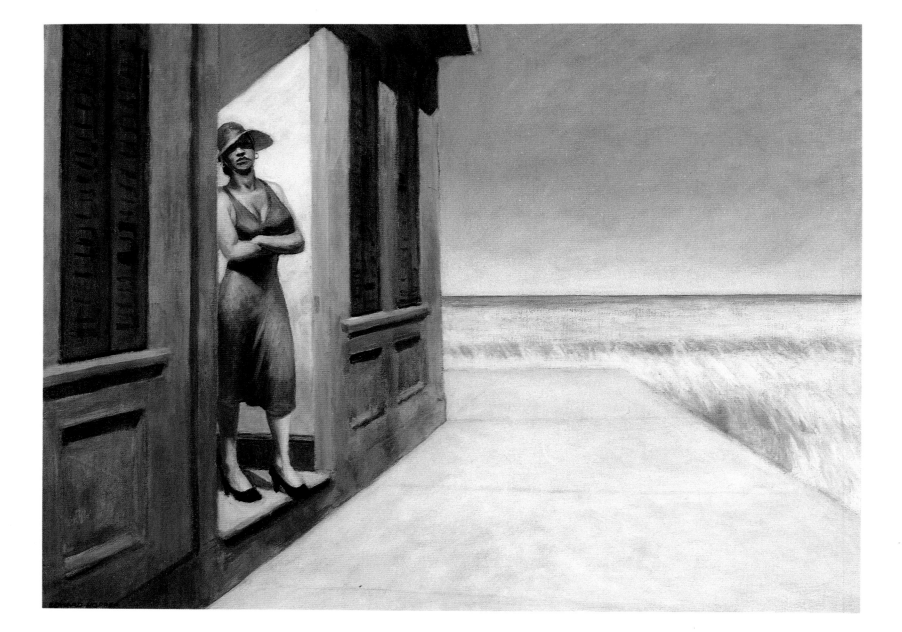

**South Carolina Morning**
1955, oil on canvas, 30×40 in.
*Given in memory of Otto L. Spaeth by his*
*family,*
*Collection of Whitney Museum of American*
*Art, New York, NY*
(67.13)

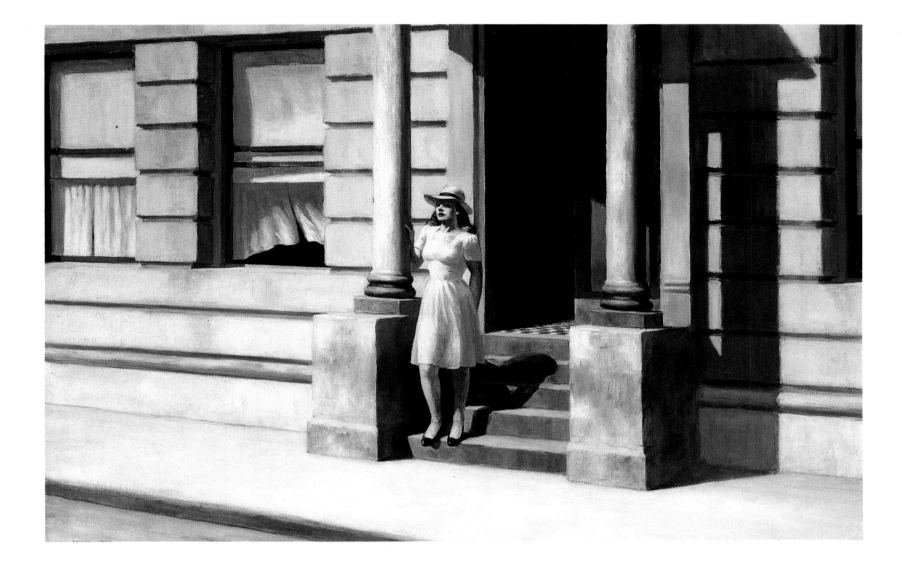

**Summertime**
1943, oil on canvas, 29⅛×44 in.
*Delaware Art Museum, Wilmington, DE*
(62-28)

**Sunlight in a Cafeteria**
1958, oil on canvas, 40¼×60⅛ in.
*Bequest of Stephen Carlton Clark,*
*Yale University Art Gallery, New Haven,*
CT
(1961.18.31)

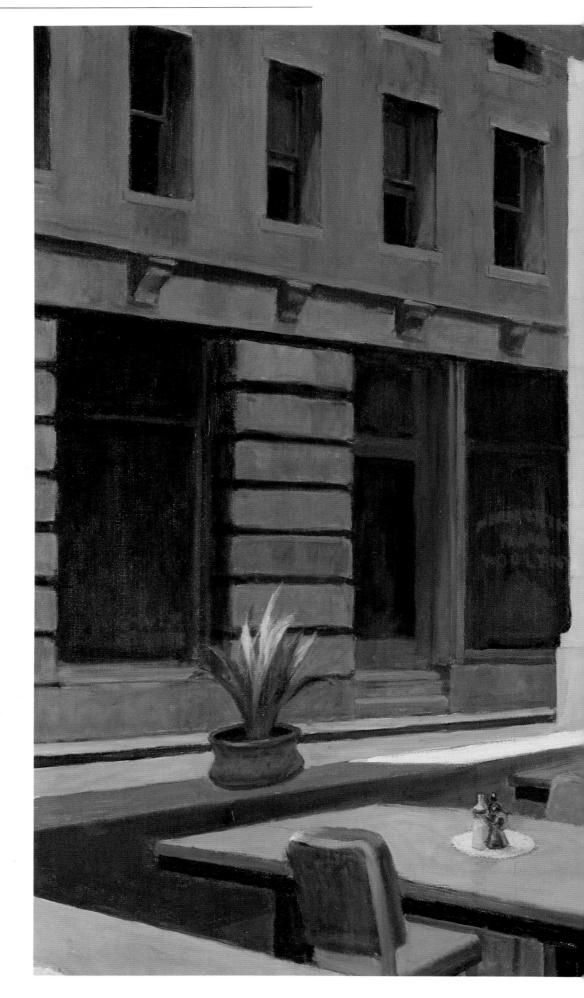

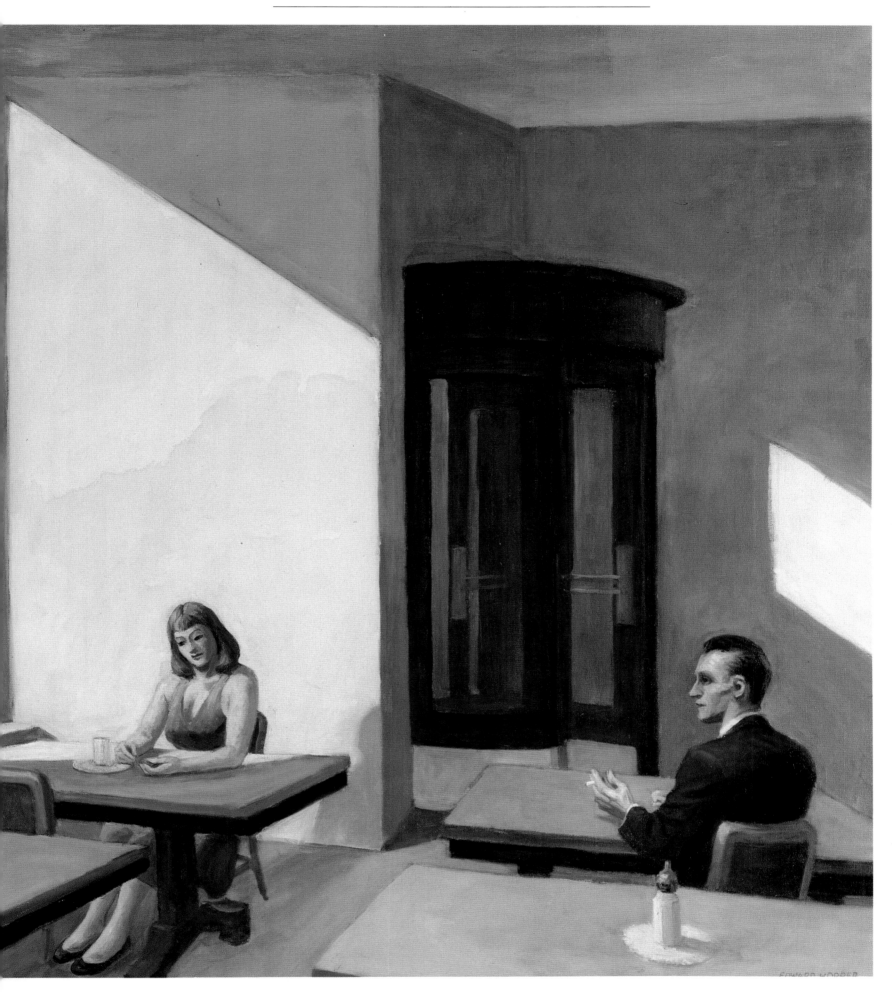

# LIST OF COLOR PLATES

**Picture Credits**
Collection of the Whitney Museum of American Art, New York: 6, 7, 8, 10(both), 12, 14, 15, 16
Columbus Museum of Art, OH: 17
Philadelphia Museum of Art, PA: 13(both)

**Acknowledgments**
The publisher would like to thank the following who helped in the preparation of this book: Adrian Hodgkins, who designed it; Rita Longabucco, who did the picture research; and John Kirk, who edited the text.